THE GREAT CENTURIES OF PAINTING

COLLECTION PLANNED AND DIRECTED BY

ALBERT SKIRA

THE EIGHTEENTH CENTURY
WATTEAU TO TIEPOLO

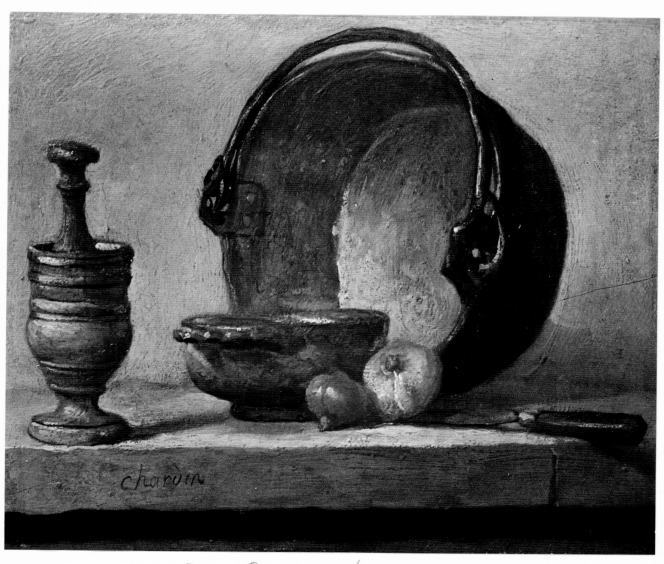

TEXT BY FRANÇOIS FOSCA

Translated by Stuart Gilbert

SKIRA

PAINTING IN THE EIGHTEENTH CENTURY

FRANCE · ITALY · ENGLAND · SPAIN · SWITZERLAND

WHEN seeking to appraise the art of the 18th century we must be careful neither to magnify nor to belittle its achievements. Nor must we confine ourselves to French painting alone, however great its charm, for there were painters—and very good ones—in other countries too. Taken as a whole, 18th-century European painting shows an immense diversity. To be sure, in certain countries where painting had flourished in the 17th century, it now lay dormant; thus it was in Flanders, Holland and in Spain until the sudden emergence of Goya who, however, should probably be regarded as an exceptional case. Whereas France, Italy and England produced not a few outstanding artists during the century.

The 18th century was eminently a period of peace and prosperity, one in which life had become easier, milder, more pleasant and comfortable. Social amenities developed and were more and more appreciated. It was no longer a life of pretense and ostentation, as in the previous century, but one of frequent, informal gatherings, the polite social intercourse of civilized beings.

These characteristics are to a large extent reflected in the art of the period, an art which would do anything rather than offend or shock, and which aimed primarily at giving pleasure. Indeed, its greatest fault was perhaps an over-eagerness to please. In it woman reigned supreme and every artist, from the architect to the humblest craftsman, strove to delight her, exalt her prestige and provide her with a setting to her taste. This was one of several reasons why French art conquered Europe and maintained its sway for so long a period. The renown of Versailles—the Versailles of Louis XIV and Louis XV—was worldwide and, stung with envy, every German princeling dreamt of a similar castle and gardens of his own. Likewise foreign visitors of distinction whose memories were haunted, after their return to their own countries, by reminiscences of the elegant Parisian *salons* they had frequented, sent for French artists to recreate around them the atmosphere of that far-off paradise on the banks of the Seine.

Yet, granting the fascinations of this art, we must admit that it lacked certain qualities: a sense of the sacred and supernatural, an appreciation of the sublime and of poetic beauty in its deeper implications. The 18th century gave the world nothing of lasting value in the way of religious painting and it treated the great myths of antiquity

as though they were scenes from some charming opera. In fact 18th-century art was much preoccupied with the theater; painters drew inspiration from it, and had no compunction about using stage perspective. Watteau put his memories of the Italian Comedy on canvas; the mythological figures of Boucher, the Coypels and Vanloos were those of the operatic stage. Fragonard borrowed the subject of his highly successful *Coresus* from an opera by Roy, while Greuze's pictures of family life, *The Village Betrothal* and *The Punished Son*, with their forced pathos and sentimentality might well be illustrations of scenes from the tearful dramas of Diderot and Nivelle de La Chaussée. As for Tiepolo, there is no doubt he would have made an excellent producer of big spectacular plays—an 18th-century Max Reinhardt.

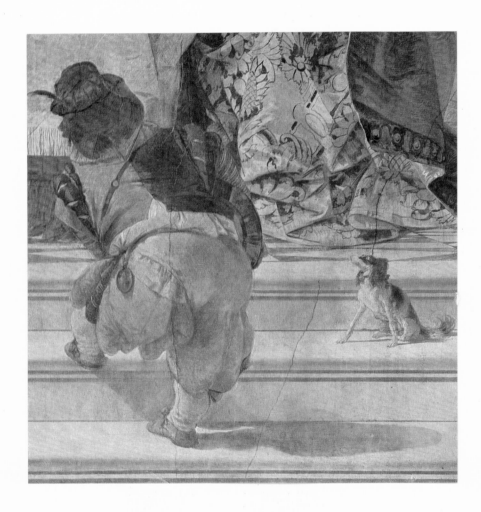

FIRST PART

MAN: PLAYER IN THE HUMAN COMEDY
FROM THEATER TO LIFE

★

THE ROMANTICISM OF MAGNASCO

WATTEAU'S DREAMWORLD
FÊTES GALANTES AND THE ITALIAN COMEDY

HOGARTH AND THE RISE OF THE ENGLISH SCHOOL

HUMANITY OF CHARDIN

EIGHTEENTH-CENTURY MAN

THE ROMANTICISM OF MAGNASCO
BETWEEN TINTORETTO AND DAUMIER

During the 18th century there arose in Italy, surprisingly enough, an artist in the lineage of Tintoretto. From the Venetian master Magnasco inherited his passion for movement and for contorted, almost dislocated forms; also his practice of splashing the picture surface with dabs of pigment that imparted vibrancy to the color. In this respect Magnasco foreshadowed Goya, Delacroix, Daumier and the Expressionists. After a long eclipse Magnasco returned to favor at the beginning of the present century. His thin, tall, twisted figures, caught in the throes of an emotional crisis and moving to the jerky rhythms of puppets in a marionette-show, seem to be taking part in some mysterious drama or participating in some occult, magical rite. It would seem that Magnasco quickened his inspiration by watching the mountebanks at fairs and the tumblers whose capering, gesticulating forms we also see in Callot's engravings. The circumstance that Magnasco's art owed so much to the theater might suggest affinities with Watteau. But temperamentally the two artists were very different; in Watteau's art we find no traces of that propensity for the grotesque which plays so large a part in Magnasco's work and was to reappear in the art of Fuseli and Goya.

MAGNASCO

In general, apart from Tiepolo, Canaletto and Guardi, the 18th-century Italian painters are little known outside Italy and are apt to be regarded, quite unjustly, as practitioners of a decadent art. While boasting no masters of the stature of Giotto, Masaccio, Raphael, Tintoretto or Caravaggio during this period, Italy nevertheless had several artists of distinction, besides the three Venetians named above.

It is true that, in Rome, painters such as Sebastiano Conca and Pompeo Batoni, intent on prolonging the existence of Renaissance classicism, succeeded only in producing completely lifeless work, based wholly on set rules. On the other hand, Giovanni Paolo Pannini, with his witty architectural landscapes and pictures of church-interiors dotted with tiny figures, is a charming *petit maître*, despite his rather dry execution. Also, though he was only an engraver, mention should be made of Giambattista Piranesi, a Venetian living in Rome, whose vigorous, monumental etchings of ancient Roman buildings were to play so great a part in the return to antiquity towards the end of the century.

The Venetian painters will be dealt with later. All of them, except Giambattista Pittoni, whose spiritless paintings exhale boredom, managed to elude the academic stupor which had overtaken Roman painting and to preserve a feeling for life and a sense of color. Also in several Italian towns, apart from Venice and Rome, this period produced artists who had a personal vision and succeeded in expressing it.

At Bergamo, Vittore Ghislandi, also known as Fra Galgario, painted remarkably lively portraits in rich colors skillfully applied with a full brush. Examples are his *Young Nobleman* in the Poldi-Pezzoli Museum at Milan, with the heavy, disillusioned eyes and crimson lips, and the old lady in black with her long, ascetic face in Count Camozzi Vertova's Collection at Costa di Mezzate (Province of Bergamo).

A belated disciple of Guercino, Giuseppe Maria Crespi of Bologna had a predilection for painting figures gradually emerging from shadows, but translucent shadows lit with glints of gold. The thick, freely laid-on texture of his painting is often reminiscent of Chardin's lavish impasto. He was as sensitive as Terborch or Pieter de Hooch to the most subtle variations of light, while his technique was much bolder than theirs, less painstaking and dry. He had a particular fondness for realistic effects, as may be seen in his decorations in the Pepoli Palace (Bologna), where he breathed new life and vigor into the old mythological or allegorical subjects; examples are his sequence of *The Seven Sacraments* and his *St John of Nepomuk confessing the Queen of Bohemia*. Their sober realism and high seriousness give the lie to the assumption that 18th-century Italian painting was wholly devoid of religious feelings.

At Naples we find the same realistic tendency, not in Solimena's huge, grandiloquent decorative paintings, spirited and inventive as they are, but in such genre scenes as Giuseppe Bonito's, which display an amazing feeling for life combined with an admirable sense of color. Similarly, at the other end of Italy, in Lombardy, a somewhat

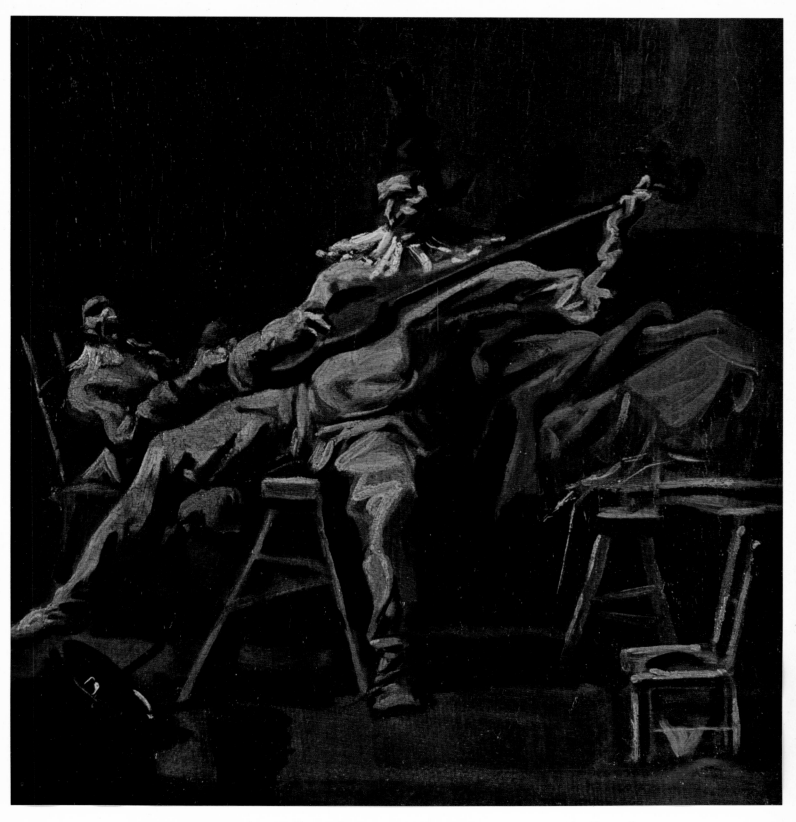

ALESSANDRO MAGNASCO (1667-1749). PUNCHINELLO PLAYING THE GUITAR. (13 ½ × 12″)
GATTI-CASAZZA COLLECTION, VENICE.

younger artist, Giacomo Ceruti, painted the everyday life of the common people with such outright naturalism and factual accuracy that canvases like *The Washerwoman* (Pinacoteca, Bergamo),*The Dwarf* (Count Salvadego's Collection, Padernello) and the *Young Woman with a Fan* (Carrara Academy, Bergamo) might seem at first sight to belong to the mid-19th century. There took place in Paris in 1934 a memorable exhibition of 18th-century French realistic painters; a like exhibition of 18th-century Italian realistic painters would, I am sure, prove no less rich, diverse and fascinating.

The most remarkable Italian painter of this period was unquestionably Alessandro Magnasco of Genoa. By the nature of his work, as well as the dates of his birth and death, he belonged as much to the 17th as to the 18th century.

From 17th-century Baroque he derived his taste for the grandiloquent and dramatic, his love of somber coloring and movement. There are very few of his canvases in which the figures are not shown in agitated, jerky attitudes, like those of persons afflicted with St Vitus's dance.

He had the typical 18th-century fondness for the stage; his paintings are theatrical through and through, full of the attitudes and mimicry of the theater. His ragged *dramatis personae* are akin to the characters of the Commedia dell'Arte that Callot had already portrayed: Francatrippa, Fritellino, Covielle—gay ragamuffins, half charlatans and half bandits, no less adroit in filching purses than in singing serenades.

His paintings with their restless, writhing brushwork, deft, emphatic strokes and small rageful touches slashed on to the canvas are monochromes in browns, blacks and golden whites, to which is sometimes added a washed-out, forlorn blue sky. He had a predilection for depicting, usually in a setting of bedraggled trees and tottering ruins, odd assortments of the 'misfits' of society, lean as rakes and clad in rags: gipsies camping by the roadside and ballad-singers twanging their guitars, beggars and hoboes, quacks crying their drugs and elixirs, straggling groups of footsore soldiers.

ALESSANDRO MAGNASCO (1667-1749). GIRL AND MUSICIAN BEFORE THE FIRE, 1710-1720. (17 × 11 ½") ITALICO BRASS COLLECTION, VENICE.

Magnasco also had a fondness for rendering scenes of monastic life; but he was far from handling them in the same spirit as, for example, Fra Angelico, Zurbaran, Le Sueur and Philippe de Champaigne. For him the religious life was simply a picturesque and somber theme, lending itself to endless variations. Thus he painted huge halls bathed in a meager light and cluttered up with the most incongruous objects—yellowed skulls, weighty tomes and smoke-blackened cauldrons—among which gaunt, emaciated monks are gesticulating, warming themselves at the hearth, beating their breasts in penitence or burying a dead brother.

This interest in the religious life, viewed solely as a quarry of picturesque themes, also led Magnasco to paint Jews meeting in their synagogues or burying their dead in cemeteries full of huge, ornate tombs. Not content with this, Magnasco even painted on two occasions Quaker meetings. As was pointed out in the catalogue of the Magnasco Exhibition held in Genoa in 1949, it is highly unlikely that the artist ever had the opportunity of attending a gathering of this kind. The efforts of certain preachers at Leghorn, Venice and Rome, round about 1650, to introduce this sect into Italy had been a complete failure. We must therefore conclude that Magnasco based these pictures either on travelers' descriptions or on imported English prints. Be that as it may, each of these scenes, as depicted by him, comes remarkably alive. His kinship to Daumier is particularly noticeable in his pictures of scenes of everyday life, open-air markets, sawyers at work in forest clearings, a barber shaving a customer; both artists have the same propensity for somber color and exaggerated gestures. Thus Daumier when he shows us a butcher cutting up the carcass of an ox imparts such frenzied excitement to the man's demeanor that he seems positively reveling in his sanguinary task. In much the same way Magnasco's barber is 'going to it' with such obvious zest that he looks more as if he were intending to slit his customer's throat than to shave his beard.

On one delectable occasion, Magnasco turned from his tramps and friars to paint a scene from aristocratic life. His *Gathering in a Garden,* now in the Palazzo Bianco at Genoa, is one of his most attractive pictures. In a garden on the outskirts of Genoa, beyond which a wide stretch of countryside can be seen, an elegant company of fine ladies, smartly dressed cavaliers, priests and monks, are engaged in conversation, playing cards or admiring the view; indeed this scene reminds us of Watteau's *fêtes galantes* and De Troy's portrayals of the amusements of the aristocracy.

It is a pity that Magnasco was not persuaded to make more escapades on these lines from his stock themes of gipsies and Capucin friars; for it must be admitted that, though a highly original artist, he had a regrettable habit of harping on the same themes with little variation and, in fact, repeating himself again and again.

Because he had a fondness for violent and even horrific subjects, and because his technique was free and vigorous, it has frequently been claimed for Magnasco that he was a forerunner of Goya; moreover there is no denying that the harmonies of browns and blacks favored by the Genoese artist are uncommonly like the range of colors employed by Goya in his paintings at the 'Deaf Man's House.'

As it so happened, three of Magnasco's dramatic subjects were treated later on by Goya. It is instructive to compare Magnasco's *Scene of the Inquisition* (Kunsthistorisches Museum, Vienna), *Attack on the Stage-Coach* (private collection, Rome) and his *Madmen's Wagon* (Enrico Bianchi Collection, San Remo) with Goya's *Scene of the Inquisition* (San Fernando Academy, Madrid), *Attack on the Stage-Coach* (Collection of the Duke of Montellano, Madrid) and his *Lunatic Asylum* (San Fernando Academy, Madrid). No more than a glance is needed to elicit the fundamental difference between the two painters. Because he himself was overcome by the horror of the scenes he depicted and because his pictorial language was infinitely richer and more original than Magnasco's, Goya succeeds in communicating his emotion to the spectator. Magnasco was interested solely in the picturesque aspect of his subjects; we like his paintings for their inventiveness, the vigorous handling of scenes and the rich quality of the medium, but they fail to move us. They are an object-lesson in the limitations of an art whose natural field is the picturesque, once the artist attempts to tackle truly dramatic subjects. The case of Magnasco is not unique; we see similar shortcomings in the case of Callot, in his *Miseries of War*, and Decamps in his *Supplice des Crochets* and his series of drawings illustrating the story of Samson.

Still, it is unjust to ask more of Magnasco than what he had in him. Neither a great painter nor a great visionary, he was none the less an artist who, in a restricted sphere and despite a regrettable tendency to repeat himself, succeeded in striking a very original note.

ALESSANDRO MAGNASCO (1667-1749). GATHERING IN A GARDEN AT ALBARO, AFTER 1735. (30×78″)
PALAZZO BIANCO, GENOA.

ALESSANDRO MAGNASCO (1667-1749). THE REFECTORY OF THE MONKS, 1730-1740. (68 ¼ × 56 ″) MUSEO CIVICO, BASSANO DEL GRAPPA.

WATTEAU'S DREAMWORLD

★

FÊTES GALANTES AND THE ITALIAN COMEDY
GILLOT · DE TROY · PATER · LANCRET
TIEPOLO · LONGHI

A LONGSIDE *the 'official' art which, patronized by the King and the nobility, was greatly in demand, there arose two other tendencies in the art of the 18th century and it was these that sponsored works of lasting value whose influence made itself felt well into the 19th century. At first sight, considering the difference of subject-matter, these tendencies seem frankly antithetical. One school devoted itself to illustrating the life of a leisured class in which gaiety and elegance reigned supreme; while the other depicted the sedate home life of the middle class. Were it not for Watteau, the work of the 'society' painters, their pictorialization of the amusements of a favored few, would have little more than a documentary value for us today; but by the alchemy of his art Watteau has transmuted the frivolous and obvious into something rich and strange. Taking his lead from the theater, he conjures up an ideal existence in an idyllic setting: a dreamworld whose elements, if borrowed from reality, are sublimated by his poetic imagination. Gillot, in drawing inspiration from the theater, merely wished to stage an entertaining incident or anecdote. Lancret and Pater, who aspired to vie with Watteau, only succeeded in more or less slavishly imitating him. Indeed it might be said that in the new art venture—apart, of course, from Watteau—only Longhi and Tiepolo made proof of any authentic originality. In the work of both of these artists we find a vein of humor, due to their shrewd appraisals of the individual man, and in this respect they link up with the English artists, Hogarth in particular. Whereas Watteau's art was, from start to finish, of the very stuff that dreams are made of. Lastly, while Chardin deals with subjects quite other than those which appealed to Watteau, he has this in common with him: that he tries to bring out the underlying poetry in scenes of daily life. Thus while in a general way 18th-century French painting abstains from humor, it is invariably and distinctively either realistic or poetic.*

WATTEAU'S DREAMWORLD

Although he was already thirty-one when Louis XIV died, Watteau none the less belonged to the 18th century, both in his general approach to art and in the very special flavor of his painting.

When he was eighteen he left Valenciennes, his native town, and set out for Paris where, for a few years, he was obliged to earn a livelihood by copying old masters and turning out devotional pictures. The first works of his own were genre scenes obviously inspired by the Dutch painters and the Le Nain brothers.

Two contacts had a decisive influence on his career; to begin with, there was Claude Gillot, whose pictures on theatrical subjects cannot have failed to stimulate certain tendencies in his art which had hitherto lain dormant. The second influence was his meeting with Pierre Crozat, a wealthy patron of the arts who owned a magnificent collection of paintings and drawings. Besides offering Watteau hospitality, Crozat allowed him to study the works in his collection at leisure, to draw and copy them. Watteau derived no less benefit from copying the series of paintings commissioned from Rubens by Marie de' Medici for the Luxembourg Palace. The painter and decorator Audran opened its doors to Watteau, while in the Luxembourg Gardens he found the scenery that was subsequently to serve as a background for so many of his pictures.

Rubens and the Venetians were Watteau's real masters, but it was Rubens who taught him most. His whole art is to be found in embryo in Rubens' *Garden of Love* at the Prado, copies of which had found their way to Paris. But, while we can discern many of Rubens' qualities in Watteau's paintings, they are always toned down; every trace of coarseness has been refined away.

Watteau turned all he had learnt from his masters to wonderful advantage and ultimately became a very individual colorist. We should have had more evidence of this had he not so often been careless about his medium. Those of his contemporaries to whom we are most indebted for information concerning him—Gersaint, Mariette and Caylus—tell us that, owing to his negligence and the excessive quantity of oil he mixed into his pigment, a number of his paintings soon deteriorated. Fortunately, a good many of his other works have remained unimpaired, and they constitute a striking proof of his innate feeling for color harmonies. An example is his *Autumn* at the Louvre, in which, anticipating the Impressionists, gold is employed for the brighter part of the figure and blue tints for the shadows. Mention should also be made of *Le Faux-pas*, also at the Louvre, for its unusual harmony of mauves and russets and the way in which it is built up with slender, flickering brushstrokes. With its mellow golden harmonies *The Halt during the Chase* in the Wallace Collection recalls Titian at his best, while nothing could be more delightful than the subtle orchestration of pinks and lilac greys in the *Fêtes Vénitiennes* at Edinburgh.

Watteau's biographer Caylus has given an account of the way in which Watteau set about painting a picture. He had a habit of sketching from nature, using as

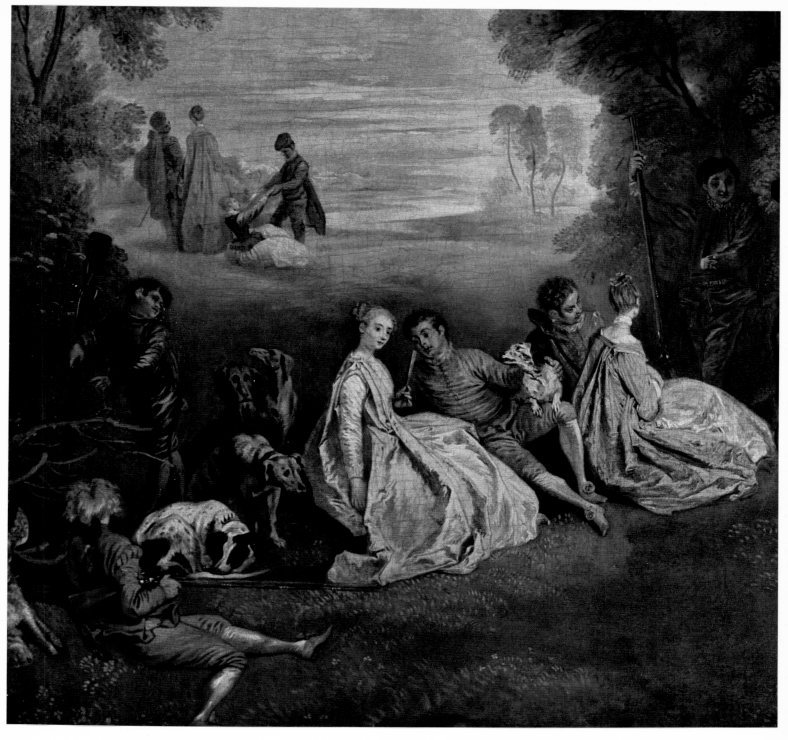

ANTOINE WATTEAU (1684-1721). THE HALT DURING THE CHASE, CA. 1720 (?). (49 × 73 ½")
FROM THE ORIGINAL IN THE WALLACE COLLECTION, LONDON, BY PERMISSION.

models all who were willing to pose for him and depicting them "in attitudes that came
naturally to them, preferably the simplest." Unlike that of the general run of painters,
it was not his practice to draft out the composition of his pictures in painted or pencilled

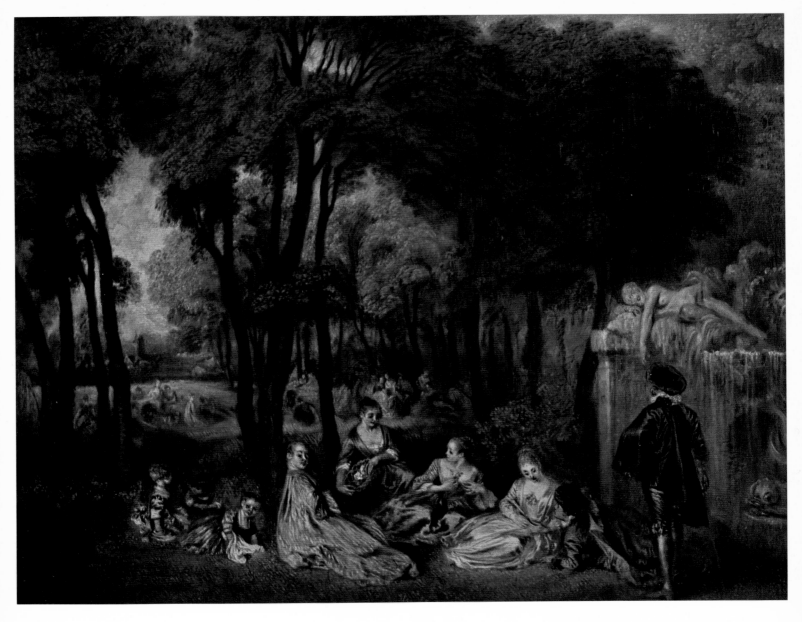

ANTOINE WATTEAU (1684-1721). THE CHAMPS ELYSÉES, 1717-1721. (12 × 16″) FROM THE ORIGINAL
IN THE WALLACE COLLECTION, LONDON, BY PERMISSION.

sketches. Leafing through his albums, he took sketches which served his turn and
arranged and adapted them so as to obtain a satisfying balance of lines and masses.

Thus, unlike his predecessors and most of his contemporaries, Watteau did not
usually start off with a clearly-defined subject in mind. When Poussin decided to paint
a picture, he began by selecting a subject from the Scriptures, mythology or ancient
history. Then he sketched out a rough draft of his composition on paper and followed
this when it came to the actual painting. Watteau, on the other hand, could not bring
himself to illustrate any definite event or to crystallize his inspiration in a set subject.
He preferred to keep his subject, or rather his theme, indefinite and vague so as to

allow the utmost freedom to the emotional responses of the spectator. Thus the titles of his pictures are interchangeable. *The Pleasures of Summer* could just as well be called *The Charms of Life* (its usual English title is *The Music-Party*), while the title *Pastoral Amusements* could equally well apply to the *Garden-Party*. Caylus was quite alive to this. "His compositions seem pointless. They do not express the operation of any passion and are consequently deficient in one of the most telling aspects of painting, namely action." A whole-hearted admirer of classical sculpture and historical painting and, it would seem, something of a pedant, Caylus failed to realize that the originality and value of Watteau's contribution to art were largely due to his refusal to choose a clearly-defined subject, and to the fact that, in his paintings, it is not the action which is intended to interest and move us, but the picture as a whole. In its willful vagueness, the subject of a Watteau canvas plays something of the part of a theme which a composer "develops," embroidering on it endless variations.

ANTOINE WATTEAU (1684-1721). THE MUSIC-PARTY. (25 ½ × 36 ½")
FROM THE ORIGINAL IN THE WALLACE COLLECTION, LONDON, BY PERMISSION.

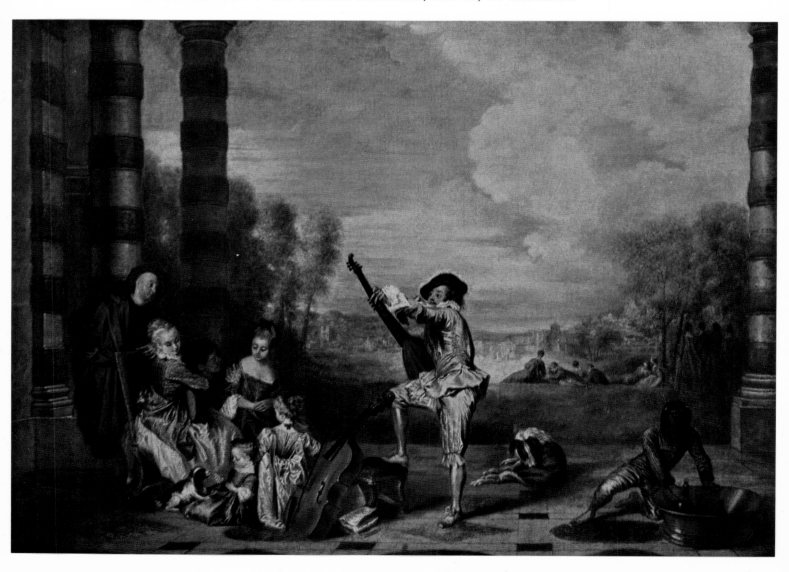

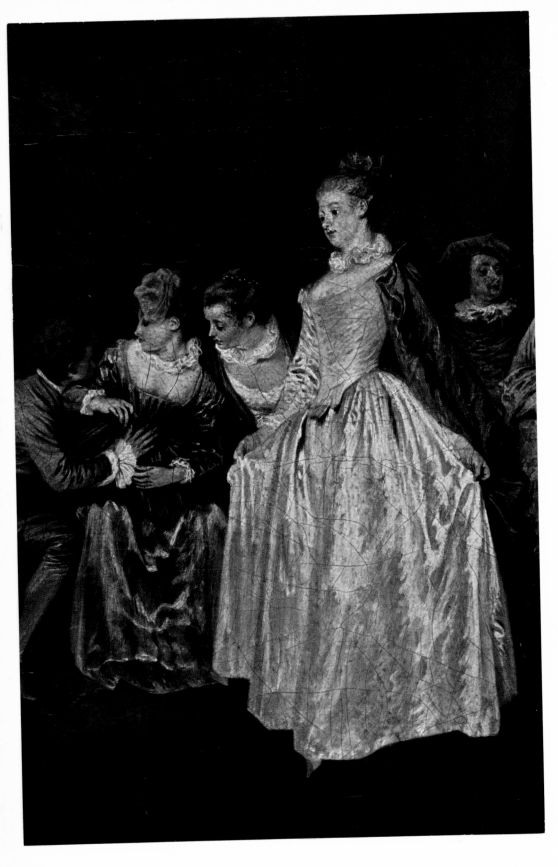

This lack of action complained of by Caylus obliged Watteau to have recourse to a very special type of composition. When Poussin set about depicting a specific incident, such as *The Finding of Moses* or *The Rape of the Sabine Women*, his whole treatment of it was conditioned by the psychological content of his subject, as well as by purely plastic considerations. Every figure was an actor in a play and had his part assigned to him. The extreme indefiniteness of Watteau's subjects, however, enabled him to concentrate exclusively on pictorial problems, and it was thus that he came to employ the method, already referred to, of grouping together his sketches from nature without regard to any specific program. Thus Watteau broke with the

It is now believed that this picture, which after all has nothing distinctively Venetian about it, owes its name to a ballet entitled *Fêtes vénitiennes*, put on at the Paris Opera in 1710. One of Watteau's best works, it confirms, incidentally, a fact recorded by his biographers: that Watteau worked at great length over his pictures, making many improvements. Thus in this canvas a certain number of *pentimenti* are discernible: the dancer's dress, for instance, has been somewhat shortened.

ANTOINE WATTEAU (1684-1721). FÊTES VÉNITIENNES, 1718-1719. DETAIL. NATIONAL GALLERY OF SCOTLAND, EDINBURGH.

carefully balanced composition which his contemporaries had learnt from the Italians and allowed himself a greater freedom and flexibility of treatment.

When we look at some of his renderings of *fêtes galantes* (those in which he did not tackle a fairly definite subject, such as *Love in the Italian Theater*) we find that there are many more reclining than standing figures. The former are bunched together in a corner of the picture and he balances this mass of figures by a single standing personage who seems to remain deliberately aloof from the others. At the same time Watteau often leaves quite a large area of his canvas empty of figures, the result being paintings which, though perhaps loosely constructed

This picture, whose spirit is so close to that of *The Music Lesson* (also in the Wallace Collection) and *The Concert* at Potsdam, is one in which Watteau has associated the foreground figures with the landscape backdrop to the happiest effect. Moreover, the landscape itself is one of the finest he ever painted; the accuracy of the tones and their harmoniousness delight the eye. The sleeping dog, as Philip Hendy has pointed out, is adapted from a dog in Rubens' *Coronation of Marie de' Medici*, at the Louvre.

ANTOINE WATTEAU (1684-1721). THE MUSIC-PARTY. DETAIL. FROM THE ORIGINAL IN THE WALLACE COLLECTION, LONDON, BY PERMISSION.

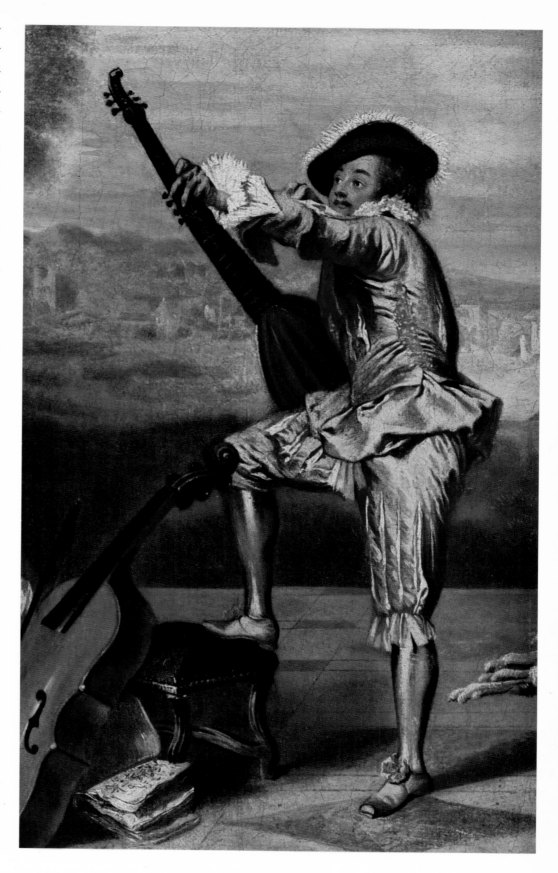

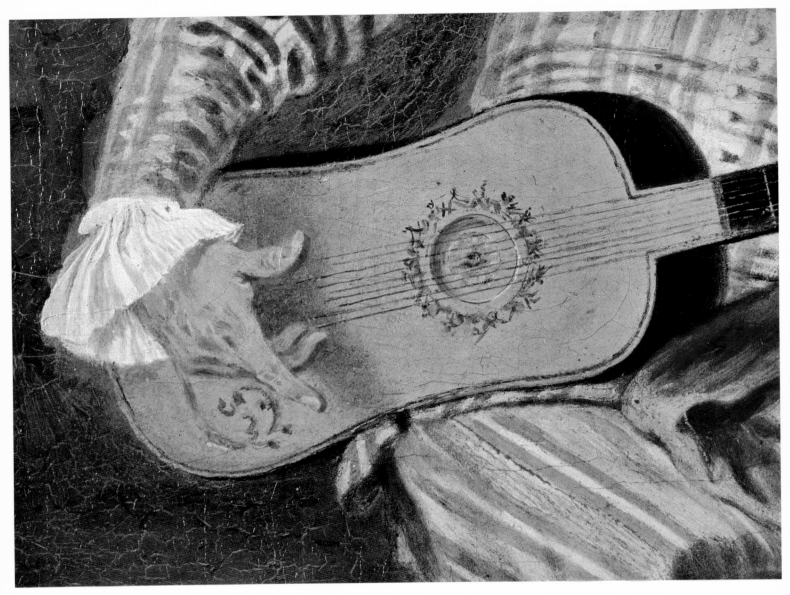

ANTOINE WATTEAU (1684-1721). THE MEZZETIN, CA. 1718-1719. DETAIL.
METROPOLITAN MUSEUM OF ART, NEW YORK.

from the academic point of view, are completely satisfying to the eye. Take for example *The Charms of Life* in the Wallace Collection, *The Concert* and *L'Amour paisible* in Potsdam, and the Dresden *Garden-Party*. Other artists have used this type of composition which gives the picture an inner rhythm, a sort of throbbing vitality. Thus Rubens used it in his *Park* in the Vienna Museum, and Tintoretto in his two versions of *Susanna and the Elders* and in some of his canvases at the Scuola di San Rocco. Degas, too, used it in several of his pictures of jockeys and dancers.

It is common knowledge that the theater, and particularly the Italian comedy, supplied Watteau with much of the subject-matter of his paintings. In 1697 the Italian

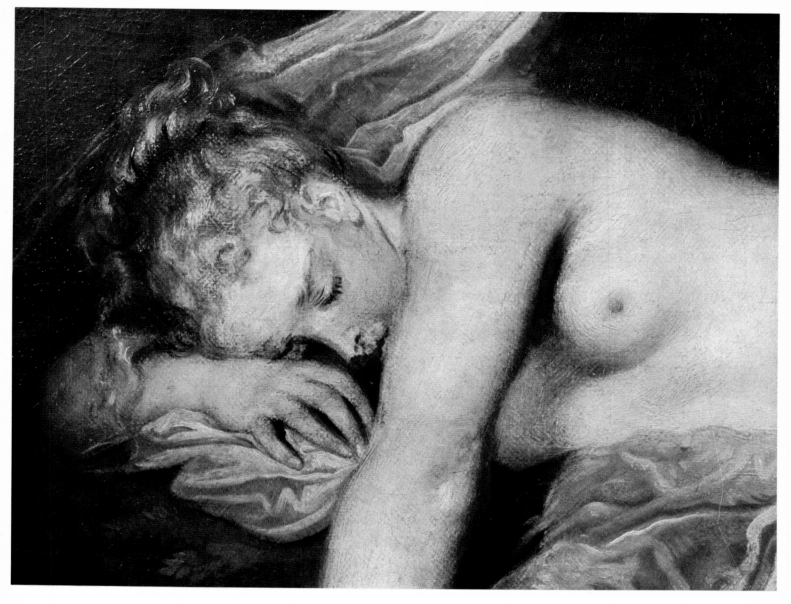

ANTOINE WATTEAU (1684-1721). JUPITER AND ANTIOPE, 1712. DETAIL.
LOUVRE, PARIS.

players, who enjoyed such a vogue in Paris at the close of the 17th century, were
ordered by the police not to perform any more of their plays because of the disrespectful
allusions they had made to Madame de Maintenon. None the less they continued to
produce pantomimes, and the Théâtre de la Foire, as well as certain amateur companies,
continued the Italian tradition, taking over such stock characters as Harlequin,
Mezzetin, the Doctor of Bologna, Scapin and the like. The plays in which these characters
appeared were broad, rather vulgar farces, full of *lazzi* or "gags," and judging from
Gherardi's collection, *The Italian Theater*, must have been very much like the films
of Laurel and Hardy.

ANTOINE WATTEAU (1684-1721). L'ENSEIGNE DE GERSAINT, 1720. LEFT SIDE. PALACE OF CHARLOTTENBURG, BERLIN.

ANTOINE WATTEAU (1684-1721). L'ENSEIGNE DE GERSAINT, 1720. RIGHT SIDE. PALACE OF CHARLOTTENBURG, BERLIN.

Watteau did not limit himself, like his senior, Claude Gillot, and as such 19th-century painters as Daumier, Degas and Toulouse-Lautrec were to do, to reproducing scenes from the contemporary theater as he had actually seen them and as faithfully as possible. His approach was different; he does not show us the stock characters of the Italian Comedy—Mezzetin, Harlequin, Isabella—disporting themselves on a stage in front of a painted backcloth, but in real landscapes, the shadowy glades of spacious parks.

But he did more than this. Watteau might well have said, with Baudelaire:

Tu m'as donné la boue et j'en ai fait de l'or...

For, in dealing with these broad farces, Watteau strips them of their buffoonery and horseplay, and eliminates every trace of vulgarity; his genius transmutes them into scenes of ravishing beauty. Retaining only what was necessary for his purpose, he creates a world of his own whose nearest parallel is to be found in some of Shakespeare's comedies and Mozart's operas. It is a world of tranquil happiness, in which silk-clad lovers whisper their vows under the spreading branches of trees tinted with autumn's gold, while a musician strums his lute or guitar as much for his own satisfaction as to entertain the others.

A century and a half later another artist was to effect a similar transmutation of reality. When we compare Renoir's idyllic depictions of Parisian boating parties painted round about 1875 with Maupassant's short stories in which what actually happened on these occasions is described with such brutal frankness, we can see how, like Watteau, Renoir kept only what would serve his purpose, discarding all that was coarse, ugly or vulgar. We find the same thing happening when we compare Renoir's *Moulin de la Galette* with Lautrec's cruelly truthful pictures of the Montmartre dance-halls. The young people who frequented the Moulin de la Galette were doubtless not renowned for their elegance or good manners but, like Watteau, Renoir has transfigured his characters. Under his magic touch, threadbare jackets and crumpled dresses become the costumes of a fairy prince's wedding; the *bal populaire*, with its dust and noise, is metamorphosed into the most exquisite and elegant of *fêtes*.

Because Watteau suffered from ill-health (he died from tuberculosis at the age of thirty-seven) and was of a shy, retiring disposition, it has been suggested that his pictures are imbued with a secret melancholy and disquietude, due to a presentiment of his early death. The Goncourts are responsible for having launched this theory and, following them, Michelet embroidered on it with errors of fact and far-fetched arguments. Indeed, he goes so far as to try to make us think that Watteau died of a broken heart because the ladies of his period were too thin!

In this opinion we have, to my mind, yet another example of a mistake very frequently committed by art historians: that of drawing conclusions from what they *know* rather than from what they *see*.

From people such as Gersaint, Jean de Julienne and Caylus, all of whom knew and admired Watteau, we learn that he was an omnivorous reader and a music-lover,

that he had much shrewdness and a caustic wit; though also that he was timid, nervous, temperamental, melancholic and never satisfied with his work.

But are there any indications of all this in Watteau's paintings? It seems to me that, if they are studied without reference to any preconceived ideas, hardly a trace is to be found in them of that all-pervading sadness which so many people, following the Goncourts and Michelet, have read into them and which these writers would never have noticed were nothing known of Watteau's life. The prevailing mood of his pictures is one of tranquil happiness; it is the mood that comes of a sense of leisure and the pleasure of mingling with people who obviously relish each other's company and are exchanging smiles and cheerful conversation.

I consider it much more likely that, just because he was inclined to be melancholy, restless, and always discontented with his work, Watteau wished, anyhow in his pictures, to enter into an imaginary world vastly preferable to the real one, because there at least he could count on finding the peace, tranquillity and happiness that everyday life denied him.

A comparison between Poussin's idyllic pictures—*Jupiter and Amalthea* (Berlin), *The Triumph of Flora* (Louvre), *Bacchanalian Revel* (National Gallery, London), and so many others—and Watteau's will show how similar they are in feeling. It matters little that Poussin's figures are half-naked or clad in floating draperies, while Watteau's wear the traditional costumes of the Italian players; in both cases, the aim is to recreate in a rustic setting a sort of Earthly Paradise, to recall the Golden Age when man was in perfect harmony with nature.

There came a day, however, when he forsook that dreamworld and returned to the realism which had inspired his early works.

This was in 1721, a few months before his death. His friend Gersaint, the picture-dealer, wished to have a sign to hang above his shop. Watteau volunteered to paint it; he wanted, as he said, "to loosen up his fingers." Gersaint would have preferred the artist to turn his hand to something a little more worthy of his powers, but realizing that Watteau would enjoy the task, he finally consented and gave him the commission. Watteau, who was already extremely ill and weak, could devote no more than a few hours a day to his work on the sign. Yet in eight mornings he completed a canvas of over five square yards in area, which, amazingly enough, does not show the slightest trace of fatigue or of the speed with which it was painted.

Watteau had demonstrated his consummate artistry in the *fêtes galantes*, in which he conjured up an imaginary world. It is no less evident in the *Enseigne de Gersaint*, which gives us a realistic *aperçu* of Parisian life during the Regency. Watteau's concern for truth, which had never been stifled by his love of fantasy and elegance and is plain to see in his marvellous sketches from nature, is splendidly illustrated by this canvas whose coloring is at once so delicate and so accurate. Thus the painter of the contemporary scene so insistently called for by Baudelaire in his *Salons* and in his essay on Constantin Guys, and by the Goncourts in their novel *Manette Salomon*, had already made his appearance a hundred years before their time in the painter of the *Enseigne*.

Even such a shrewd, keen-eyed observer as Degas never painted anything so convincing, so true to life, as Watteau's rendering of the attitudes of the customers in Gersaint's shop. Whatever may be the merits of such works as Degas' *Cotton Office in New Orleans* and his *Dancing Class* in the Louvre, both paintings strike us as a shade too self-conscious and thought-out when we compare them with Watteau's *Enseigne*. They lack that supreme ease, the "art that conceals art" inspiring this painting undertaken by Watteau "to loosen up his fingers."

We can but reiterate the opinion expressed by the Goncourts that, apart from the academic painters whose vast canvases contain nothing but hollow rhetoric, and apart from Chardin, who was a law unto himself, all the 18th-century painters, from Boucher to Fragonard, were more or less in Watteau's debt.

Was he not (along with Tiepolo) the finest painter of nudes to whom his century gave birth? And also the truest to life; as we see when we observe the golden flesh-tints of his *Antiope* and the graceful, so accurately observed form of his Venus unveiling herself in *The Judgement of Paris*. Similarly when we examine closely the hand of his *Mezzetin* and that of *Antiope*, we are struck by their amazing lifelikeness. For though Watteau conjured up a dreamworld, this dreamer of exquisite dreams could look reality in the face and render it with nice fidelity.

Indeed it is because, while revealing the artist's inner vision, the art of Watteau is so firmly rooted in reality that so many painters of a later day have sought to elicit from his *œuvre* the lesson of the master. Leaving it to the *littérateurs* to devote brilliant, if often specious, pages to Watteau's underlying melancholy and the influence of a premonition of an early death on his art, they—the painters—have studied his limpid color, his lively, spirited drawing with understanding eyes. Thus they have admired his skill in combining veracity with elegance and the way in which his figures blend into the landscape, a landscape which has never the look of a mere backcloth. Watteau, in fact, can vie with the very greatest of the French masters of landscape-painting, and when we compare his landscapes with those (which he certainly saw) of Rubens, we realize how much nearer they come to nature.

In this respect Watteau may justly be said to have anticipated the discoveries of the Impressionists; also, his affinities with Renoir have often been pointed out. Both artists exulted in the beauty of women, they have the same gift of sublimating the real without devitalizing it, and the same desire to record on canvas those rare, exquisite moments when by some trick of magic we have glimpses of a lost, golden age.

FÊTES GALANTES AND THE ITALIAN COMEDY

During his lifetime Watteau had two imitators: Jean-Baptiste Pater and Nicolas Lancret. I use the word "imitators" advisedly, for, to my thinking, the term "disciple" or "pupil" had best be reserved for artists who after working under a master add something of their own to what they have acquired from him. Not that either Pater or Lancret was a negligible artist; certainly not the former, who sometimes shows a very delicate feeling for color.

JEAN-BAPTISTE JOSEPH PATER (1695-1736). THE BATHERS, CA. 1735. (25 ½ × 32 ½ ")
MUSEUM, GRENOBLE.

JEAN-FRANÇOIS DE TROY (1679-1752). THE HUNT BREAKFAST, 1737.
FROM THE ORIGINAL IN THE WALLACE COLLECTION, LONDON, BY PERMISSION.

When Watteau returned to Paris after spending some months at Valenciennes during the winter of 1709-10 he was accompanied by his youthful compatriot Pater. Watteau had been specially asked to "shape" him, but the young pupil found his

master "too fussy and irritable" and very soon set to working by himself. During the last months of his life, repenting of his harshness, Watteau sent for Pater and assigned to him the task of completing his unfinished works.

Born in Paris, son of a coachman, Lancret began by studying under Gillot; Watteau however, who had taken a fancy to the lad, strongly advised him to emancipate himself from Gillot's influence and methods and to go to school with "the master of all masters, Nature." Instead of doing this Lancret took to imitating Watteau, and to such effect that some of his pictures were taken for works by Watteau, who was bitterly mortified, the result being an estrangement between the two artists.

Watteau's art is so much an exteriorization of his own secret dreams that, as a result of following their master so closely and so faithfully, Pater and Lancret produced works which are little more than pale reflections of his, not without charm, but none the less tarnished and attenuated. A comparison of their paintings with Watteau's makes us feel their vagueness and slightness of form, the weak, hesitant brushstrokes; while the color, though agreeably delicate, lacks vibrancy and resonance. In their work Watteau's very individual grace becomes mere prettiness, verging on affectation.

In his early days Watteau worked for some time in the studio of Claude Gillot, his senior by eight years, and it seems probable that Gillot, who at the time was devoting himself to subjects taken from the open-air theater, opened Watteau's eyes to the thematic possibilities of the Italian comedy. Gillot, it would seem, should be placed in that category of artists who, though naturally gifted and full of ideas, never get the best out of themselves for lack of a solid grounding in their youth. As for Pater and Lancret, all they aimed at was to follow the paths opened up by Watteau, who had created a genre which was enjoying great success. The case of Gillot is different; nothing if not versatile, he explored many fields of art: drawing, etching, designing theatrical costumes and accessories; and he made an album of cartoons for tapestry portières. The essential difference between Gillot's paintings and Watteau's is that the former depicted theatrical scenes exactly as he saw them on the stage; whereas Watteau transforms and sublimates his memories of the Italian comedy. As in the case of Pater there was, after a period of warm friendship, an estrangement between Watteau and Gillot due most probably to Gillot's jealousy of his young pupil's markedly superior ability.

What was the origin of this fashion for theatrical subjects launched by Gillot? Probably, like the rage for all things Turkish and Chinese, for the exotic and the eccentric, it was due to a reaction against the austerity enjoined by the aging monarch, Louis XIV. Masquerades, fancy-dress balls, anything that offered an escape from the daily round was eagerly welcomed by a public in revolt against the humdrum.

While the genre of *fêtes galantes*, a deft mingling of elements taken from the Commedia dell'Arte and the classic pastoral, was the creation of Watteau and his followers Pater and Lancret, another painter, Jean-François de Troy, applied himself to depicting the life of the aristocracy. Like so many artists of his day, de Troy aimed above all at pleasing his public and his brilliant career was proof of his success in this endeavor. All the people in his paintings are young, good-looking, elegant, and wear their magnificent

CLAUDE GILLOT (1673-1722). SCENE FROM "THE TWO COACHES," CA. 1707. (52½×62")
LOUVRE, PARIS.

clothes 'with an air'. Yet these scenes of idle luxury have not the same nostalgic appeal for us as Watteau's little groups of figures under trees touched with the first glints of autumn's gold. In a picture by Watteau we seem to overhear a soft, far-away music mingling with the sighs and whispers of the lovers; all that de Troy suggests is the tittle-tattle of fine gentlemen and ladies exchanging the latest gossip. Indeed we have only to look at their round, characterless faces, vacuous as those of tailors' dummies, to realize the nature of their conversation. In Watteau's pictures, on the other hand, every face, even the least important, is brimful of life and personality.

In short, de Troy made no attempt to penetrate beneath the glittering surface of the life of a privileged few in an age of frivolity and extravagance. Unlike Saint-Simon and Laclos he did not seek to depict the real nature of a social group all for noise and movement and regarding solitude, even for a moment, as the greatest of all ills. Enough for him if he could feast his eyes on the colorful spectacle provided by these butterflies of a day—a day fated to come to a disastrous close... The work by de Troy which we reproduce displays much verve, while the full-bodied color suggests that he had studied Rubens to good effect.

NICOLAS LANCRET (1690-1743). AN ITALIAN COMEDY SCENE. (11 × 14″)
FROM THE ORIGINAL IN THE WALLACE COLLECTION, LONDON, BY PERMISSION.

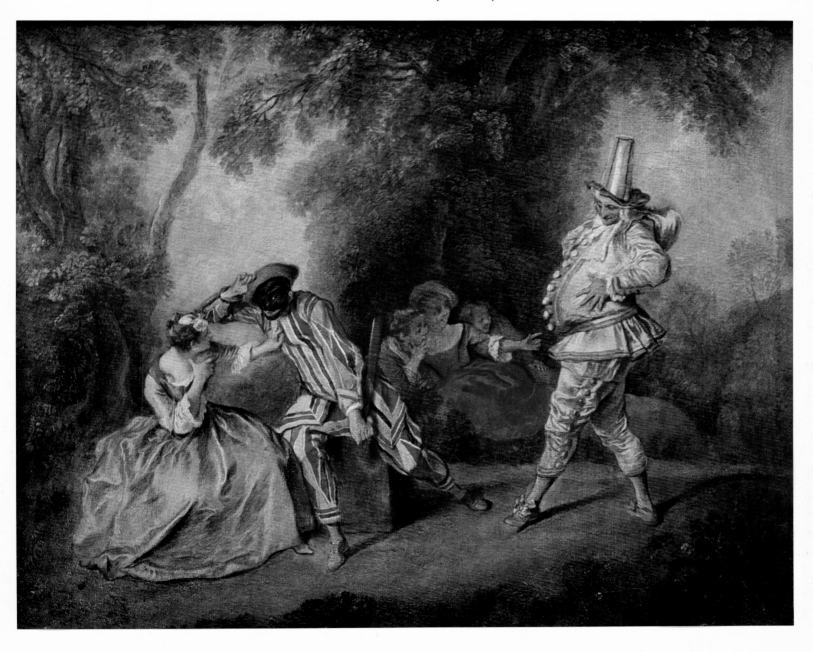

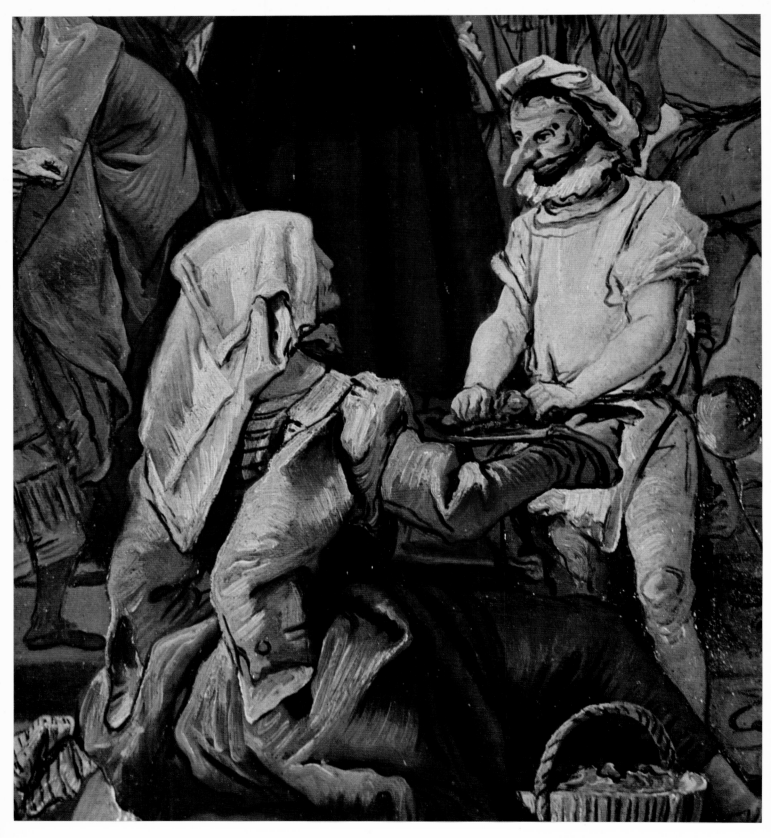

GIAMBATTISTA TIEPOLO (1696-1770). THE CHARLATAN, 1756 (?). DETAIL. CAMBO COLLECTION, BARCELONA.

THE VENETIANS: TIEPOLO AND LONGHI

It would have been indeed surprising if the Venetian painters of the period had failed to include the masquerade in their repertory of themes, considering that, far more than the Doge, pleasure held sway in 18th-century Venice, whose gorgeous carnival was the talk and envy of all Europe.

Forgetful of her earlier exploits in commerce and war, Venice gave herself over to the enjoyment of a series of public festivities extending through the year, the most dazzling of these being the carnival, which lasted no less than six months, and during which everybody went around in masks or fancy-dress: an admirable way of escaping from the humdrum daily round and playing a delightful game of make-believe. Thus at carnival-time the humblest Venetian could play at being a Sultan, and any servant-girl at being a Chinese princess.

Deserting for a while the gods, goddesses and heroes of ancient legend, Giambattista Tiepolo amused himself conjuring up the masks and characters of the Commedia dell'Arte, particularly in his frescos at the Villa Valmarana. This he did with that quite amazing virtuosity which had become a second nature with him and indeed gives the impression that, for him, painting was simply a delightful pastime.

This playground of the imagination at its freest that was the masquerade reappears in Tiepolo's etchings (which we may well believe Goya to have studied). In these prints, whose loosely woven linear texture is saturated with light, he escaped the necessity of illustrating any set, well-defined subject, limited to any specific time or place. These etchings are a carnival in themselves, with their imaginary landscapes, in which frolicsome nymphs and the armor-clad heroes of antiquity figure amongst bearded Turks fiercely scowling beneath their turbans and Punchinellos in grotesque masks.

In his witty, daintily planned canvases, steeped in glittering colors, Giambattista Tiepolo's son, Giovanni Domenico, tries to show exactly how Venice looked at carnival-time. Through the *campi* and narrow streets of Venice in holiday mood move *gentildonne*, their faces hidden under flimsy masks, Harlequins and Doctors of Bologna, guffawing Covielli, muftis, dervishes and mustachioed Spaniards with starched ruffs. Quacks are vociferously crying their wares or pulling teeth, while a man and a woman suddenly start dancing a *furlana* on the outskirts of the crowd, out of sheer blitheness of heart.

Tiepolo's etchings, in which he gave free rein to his imagination, are companion-pieces to those enchanting fantasies in which Carlo Gozzi transported the characters of the Commedia dell'Arte—Pantaloon, Spaviento, Brighella and Tartaglia—to an imaginary Orient or the China of a decorated screen. Pietro Longhi's small canvases, delightful little vignettes of the contemporary daily life of Venice in his day, are the counterpart of Goldoni's comedies of middle-class and low life in his native town.

Pietro Longhi left no aspect of Venetian life of the period untouched by his art: the crowds at the Ridotto and the throngs around the gaming-tables; the travelling marionette-show, the astrologer of the Piazzetta, the fat black rhinoceros on view in a menagerie. But what he obviously enjoys most of all is depicting the life of an

elegant Venetian lady of fashion in all its golden hours, not with the object of pointing a moral in the manner of Hogarth, but in the spirit of a faithful chronicler. Thus we see her sitting before a mirror at her toilet, drinking chocolate, receiving her hairdresser and singing while a priest accompanies her on the harpsichord. And, of course, Longhi, like the others, shows the Venetian scene at carnival-time with its masks and fancy-dresses. All the same, the very real documentary value of Longhi's painting must not blind us to their artistic shortcomings, for as a painter he was definitely inferior to his fellow-artists, Tiepolo, Piazzetta, Canaletto and Guardi. With their uncertainty of form, their banal, no more than approximative color and the exiguity of the medium, his paintings cannot be regarded as the work of a really first-rank artist.

It is a remarkable fact that the qualities of observation and the technical proficiency we find in Longhi's drawings do not appear in his paintings. "Longhi's drawings," as the Goncourts wrote in their *L'Italie d'hier*, "are sketches hastily dashed off in brown chalk, and picked out with white, on faintly chocolate-tinted paper; the pencil has moved so freely and to such happy effect that we can almost believe we see it twisting and turning between the artist's fingers, and, like drawing done with a 'stump,' the outlines are blurred,

PIETRO LONGHI (1702-1786). THE RHINOCEROS, 1751. MUSEO CA' REZZONICO, VENICE.

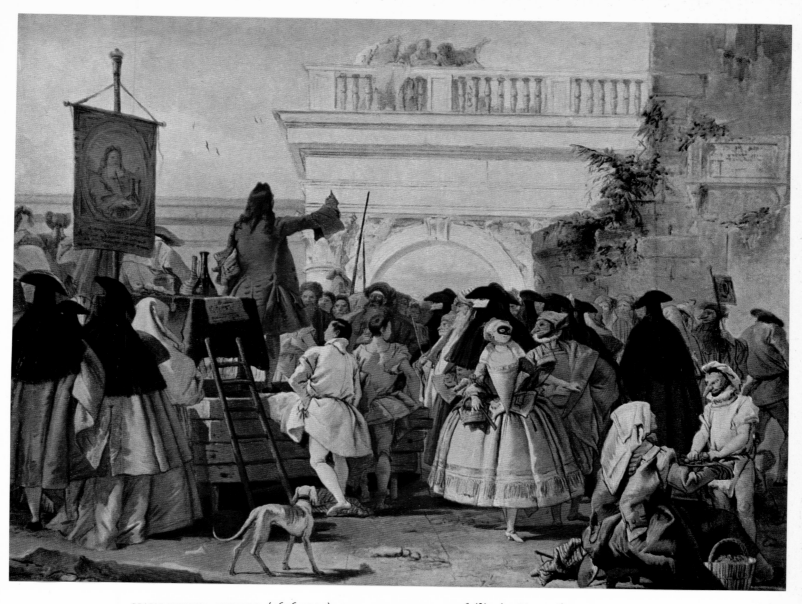

GIAMBATTISTA TIEPOLO (1696-1770). THE CHARLATAN, 1756 (?). (30½×43″)
CAMBO COLLECTION, BARCELONA.

artistically softened." Incidentally, the Goncourts very aptly point out the similarity between Watteau's drawing and Longhi's, with its black slashes done with a blunted pencil.

What a vast distance had been covered in the two centuries between Veronese and Longhi! Nevertheless, 18th-century Venice still had painters capable of decorating the apses of churches, painting big altar-pieces and conjuring up the pomp and luxury of bygone Rome on palace walls; and it was on such tasks as these that Tiepolo, greatest among them all, lavished his exuberant genius.

Other painters, however, such as Rosalba, Canaletto, Guardi and Longhi, turned away from the great religious and mythological subjects and preferred to deal with

contemporary life in their portraits, landscapes and genre pieces. But is it really right to speak of "preference" in this context? We are far too prone to assimilate painters of the past to those of today and assume that they had complete freedom in choosing their subjects. The truth is that there was much more of the artisan in their make-up than we might think, and they did not consider it in the least discreditable to conform to the tastes of the rich art-lovers of the day and paint the subjects their patrons wanted. In the 18th century, Venice was a tourist center, crowded with wealthy foreigners, particularly Englishmen, who were eager to take back with them souvenirs of the Queen of Cities. Thus Canaletto painted his views of Venice, the Grand Canal and the Rialto with an eye to the contemporary tourist, just as at a later day Diday and Calame were to paint innumerable views of the Oberland, the Jungfrau and the Giessbach Falls, when the Swiss Alps became the tourist's Mecca.

HOGARTH AND THE RISE OF THE ENGLISH SCHOOL

REYNOLDS · GAINSBOROUGH · STUBBS

V AN DYCK *with his portraits of the aristocracy had established a tradition whose influence permeated English painting throughout the 18th century, up to the time of Lawrence. None the less Hogarth was the true founder of the English school. Like the Impressionists Hogarth resolutely turned his back on the canons of aesthetics sponsored by Italian art, and fixed his eyes on nature. At once a realist and a shrewd psychologist, Hogarth might well have turned his hand to novel-writing and competed with Fielding and Smollett on their own ground; he elected to be a painter, and a great one. Renoir was enraptured by the warm vitality of* The Shrimp Girl *and Reynolds himself in that wonderfully lifelike portrait of Admiral Heathfield demonstrated how much he owed to Hogarth. Moreover this portrait invites another confrontation; looking at it, we are instantly reminded of Goya's* Charles IV *and of the Spanish master's verve, his realism so happily combined with humor. Gainsborough, however, brings us back to Watteau's dreamworld; like Watteau, the English artist invests his models with poetic glamour, his color has the same pearly luster, his brushwork the same vibrant sensitivity. In some respects is not* The Blue Boy *an English brother of* L'Indifférent?

HOGARTH AND THE ENGLISH SCHOOL

William Hogarth is one of the most remarkable figures of that English school of painting which, stemming from Van Dyck and Lely, came to so brilliant a close with the dazzling virtuosity of Lawrence.

Hogarth began with engravings and 'conversation pieces,' small group portraits of families or gatherings of friends. He was not yet thirty when, like Greuze, he decided that henceforth his art should serve a moral purpose and inculcate a lesson. But in contrast to Greuze's rather mawkish sentimentality, Hogarth displayed a sturdy, democratic bluntness and mercilessly trounced the vices of the rich and the nobility.

He once remarked that he wanted his pictures to be read like books, thus echoing a passage in which Diderot praised Greuze for being "the first to introduce contemporary mores into art and to link together scenes in such a way that they could easily be turned into a novel."

Between 1731 and 1755 Hogarth made several series of story-pictures on these lines: *A Harlot's Progress, A Rake's Progress, Marriage à la Mode* and the *Election* series. Each of these is like an edifying, satirical novel, of which each painting serves to illustrate a chapter.

It is true that in painting these scenes Hogarth had to draw on his imagination, and his shortcomings may be due to the fact that he was one of those artists who need to have the living model before their eyes. None the less, owing to some odd kink in his nature, he seems to have set himself against sketching from life and preferred to rely on his memory.

It must be admitted that it served him well on two occasions. First in his *Masked Ball at Wansted*, a small canvas in which the color is delicious and there is a pleasant ease in the execution. The work abounds in well-observed details, for instance the man standing at the window in the background, who, having taken off his wig, is mopping his bald skull and gazing out at the moon. There is not a little mischievous humor in his rendering of the antics of the dancers, fat or lean, and, at the same time, using his artist's eye, he has supplied them with an effective foil in the heap of black three-cornered hats piled in the foreground. The other canvas is the one known as *"O, the Roast Beef of Old England!"* or, more briefly, *Calais Gate*.

It is a pity that his very real gifts as a painter are so little in evidence in his moralistic picture dramas. True, this has never been the least obstacle to their popularity. They have even been adapted for the stage. This would have rejoiced a moralist like Diderot, no less than the following anecdote, which would certainly have inspired his pen to half a dozen rhapsodic pages. One day an English lord saw a coachman ill-treating his horses. "You rascal!" he shouted. "Haven't you seen Hogarth's pictures?"

No mean portraitist, Hogarth left some outstanding achievements in this genre, one thoroughly congenial to his realistic eye, though we cannot say as much for his short-lived and unsuccessful attempt to set up as an 'historical painter'. His portraits,

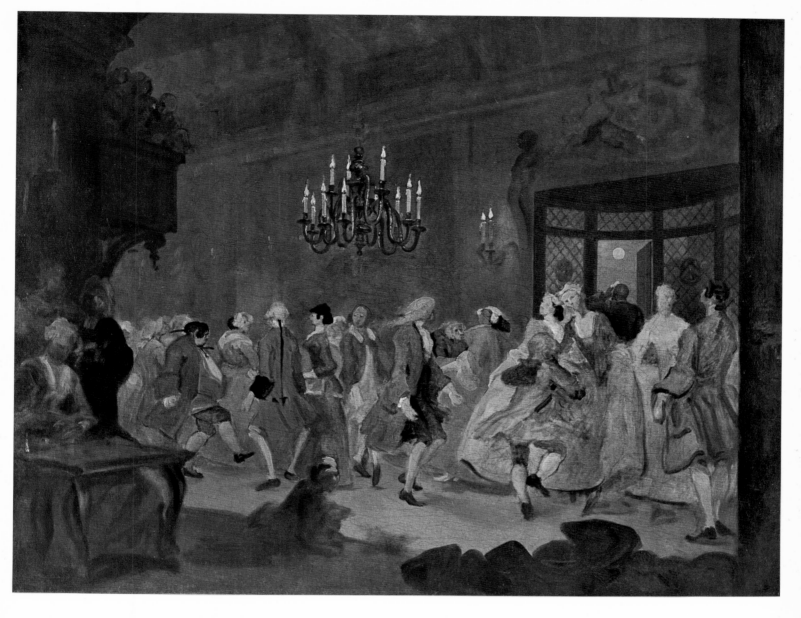

WILLIAM HOGARTH (1697-1764). MASKED BALL AT WANSTED, CA. 1745. (25×30½")
SOUTH LONDON ART GALLERY, LONDON.

if sometimes a trifle heavy-handed, are broadly, freely treated, lifelike, forceful and sincere; moreover, they reveal his color-sense and his delight in rich, juicy pigment.

Thus we have the delightful portrait of his sister in the National Gallery, London, and that *Unknown Woman* in the Museum of Geneva, her white bodice bedecked with a bunch of many-colored flowers. No less interesting is the canvas in the National Gallery in which he amused himself painting his household staff. They are all there: three mob-capped serving-women, two of them too much alike not to be sisters; an old man with flabby cheeks and fleecy locks; the factotum of whom we feel that, if

he lacks intelligence, he is an honest servitor, devoted heart and soul to his employer's interests; and finally a boy with big, earnest eyes, telling of a desire to do his work well and faithfully to serve his master.

But the portrait which is certainly to be acclaimed as Hogarth's masterwork is that delightful *Shrimp Girl*, with her candid smile and cheeks reddened by the sea-winds. With a limited palette, a grey-brown monochrome brightened with tonalities of other colors, browns, pinks, russet-reds, bronze, vermilion, Hogarth has made a picture sufficient in itself to ensure his lasting fame. In it we find the technique of Rubens and Van Dyck, their broad, sweeping brushwork, their colors swimming in amber-golden oil. Hogarth links up here with Goya no less than with Fragonard.

Many of Hogarth's portraits are extant, mostly of men. We may well surmise that his brutal forthrightness did little to attract the aristocracy to his studio—and women even less. Exquisite as is his *Shrimp Girl*, we can hardly imagine Hogarth producing the flattering portraits, stressing their elegance and beauty, that the society ladies of the day would have expected of him.

Nor is it surprising that after him there arose a school of portrait-painters who paid less heed to truth than to their patrons' wishes, and were more in the Van Dyck tradition than he had been. True, Hogarth derived much of his technique from the great Fleming, but not his ideas of what the portrait should be; indeed Van Dyck's aristocratic refinement and Hogarth's uncompromising fidelity to life are poles apart. A distinguished group of English painters—Reynolds, Gainsborough, Opie, Hoppner, Raeburn, Romney, Lawrence—sponsored a new kind of portrait that was exactly what the high society of the period appreciated: a likeness which, while retaining something of the dignity of Van Dyck, was more intimate, personal, easy-going.

However, we must not overstress the differences between these portraits and Van Dyck's. Some have seen in their backgrounds of landscape or foliage an indication of the 18th-century Englishman's love of nature. Actually these backgrounds (often as not the work of a pupil acting on the artist's instructions) are treated quite as conventionally as those in Van Dyck's portraits. They lack the accent of reality, the natural lighting and those hazy greens and blues of distance which we find in Velazquez' portrait backgrounds, and which make the latter the most convincing landscapes known to art until the 19th century.

Was or was not Reynolds a great painter? Opinions differ on the two sides of the Channel. It is only natural that the British should be disposed to assign a high place to an artist who, to their thinking, depicted so well the fine flower of the English race: the most attractive society ladies and the most eminent statesmen and men of letters. It is equally natural that continental critics, who have not these special motives, should maintain that Reynolds owed too much to his predecessors—Rembrandt, Rubens, Titian, Van Dyck—to be regarded as a front-rank painter and moreover that, especially in his portraits of women, he had too great a tendency to truckle to the wishes of his sitters, to the detriment of his art. Perhaps the truth of the matter lies between these two extremes, whose error stems from a failure to sort out Reynolds' *œuvre*.

WILLIAM HOGARTH (1697-1764). THE SHRIMP GIRL. (25 × 20½″) NATIONAL GALLERY, LONDON.
REPRODUCED BY COURTESY OF THE TRUSTEES

For some of his portraits have that compelling power which we sense instinctively in the work of a great master; in these the artist's borrowings from his predecessors have been almost wholly integrated by him. Reynolds is seen at his best in his portraits of men: of himself, of *Sterne*, of *Johnson* and of *Lord Heathfield* (probably his masterpiece). But in some of his portraits of women, too, he succeeded in resisting the wishes of his fair sitters and, ceasing to be the fashionable portraitist, let his true painterly instinct guide his brush. Thus his *Kitty Fisher* (Granville Proby Collection), *Countess Spencer and her Daughter* and *Mrs Robinson* (Wallace Collection) are more successful than certain more famous portraits which suffer from an over-emphasis on elegance and a rather tiresome display of 'slickness' in the execution. Still more irritating is the mawkish sentimentality of some of Reynolds' works, such as the *Infant Samuel*, prototype of those pictures of children, meretricious to a degree, to which, at a later date, Millais owed his vast success. There was, in fact, a strange dichotomy in Reynolds' character and it is interesting to see how in his *Discourses* he enounces theories markedly contrasting with his own practice; how he extols Michelangelo and Raphael, while disparaging those very artists who were his constant masters: Titian, Veronese and Tintoretto.

It is more charitable to overlook those works, often vapid and ineffective under their veneer of elegance, in which Reynolds pandered to the taste of his high-born sitters; and to remember only those in which he gave himself heart and soul to the sheer joy of creation.

Thomas Gainsborough started his career painting landscapes and small portraits at Ipswich, in Suffolk, where he had settled with his young wife. During this period he often posed his models in the open countryside, a setting enabling him to indulge his taste for landscape. Harmonies in grey and golden-yellow, these canvases have a truth to nature, a sincerity and a simplicity which remind us of Corot's scenes with figures. Had he persevered in this direction, he might well have developed into a far greater painter than the Gainsborough we know. Such works as the portraits of Heneage Lloyd and his sister (Fitzwilliam Museum, Cambridge), of the Browns (Sir Philip Sassoon's Collection) and of Robert Andrews and his wife (in the G.W. Andrews Collection) are ample evidence of this.

But Gainsborough let himself be persuaded by a dilettante, Philip Thicknesse, who had taken a fancy to him, into leaving his simple life at Ipswich and moving to Bath, then the most popular health-resort and pleasure-ground in England, and very soon his personal charm and talent led the fashionable world to flock to his studio. Amongst its habitués were the famous writers Sterne and Richardson, and that great actor Garrick, all of whom sat to him for their portraits. A sensitive and amiable man, Gainsborough seems to have had little strength of character and there can be no doubt that his art was injuriously affected by his desire to please the frivolous, pleasure-seeking visitors to the fashionable spa.

Highly successful as were many of his portraits of men, it was in those of women and young people that he excelled. He had a marvellous knack of rendering the flower-like charm of childhood, the pearly luster of young girls' complexions, the soft glow of their big, dreamily wondering eyes. As compared with Gainsborough's shy, sentimental *jeunes filles en fleur*, Reynolds' smart, self-assured society beauties strike a frankly materialistic note. All the same there is something faintly artificial in the poetry with which Gainsborough steeps his portraits of women; we catch ourselves thinking of the medium who, though firmly believing in the spirits with whom she communicates, resorts to trickery when the 'power' fails her.

Though it, too, followed the Van Dyck tradition, Gainsborough's technique was more original, less eclectic than that of Reynolds who drew constantly on the Venetians, on Correggio, Rembrandt and Rubens. When we see how Gainsborough sprinkles his canvas with vibrant touches, imparting a shimmering quality to his tones, we well may wonder if he had not seen and studied Watteau's art. His weak point is form. In many of his large portraits there are signs of over-hasty execution; one does not sense the body under the dress, while the hands are often sadly conventional. Gainsborough's worst defect is a tendency towards flaccidity, a lack of well-placed accents. His work is uneven; alongside awkwardly planned canvases in which he shows an almost servile deference to his high-society models, we find portraits of women that

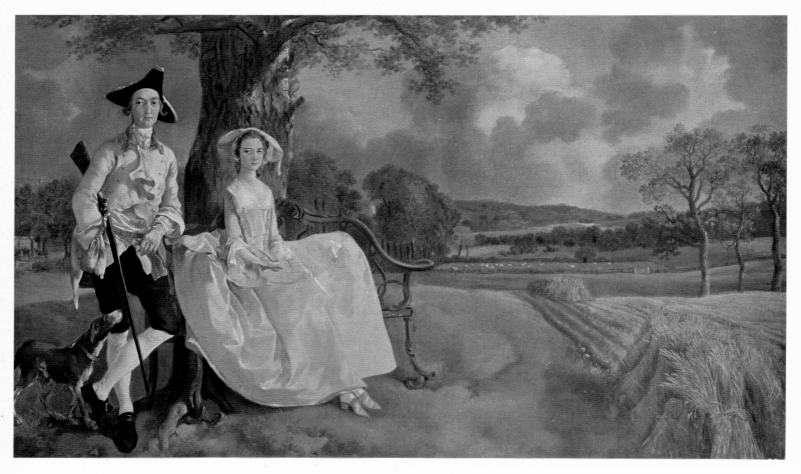

THOMAS GAINSBOROUGH (1727-1788). ROBERT ANDREWS AND HIS WIFE, CA. 1748-1750. (27 ½ × 47")
ANDREWS COLLECTION, REDHILL, ENGLAND.

are wholly delightful. Though he fell short of being a truly great painter and portraitist, few painters have succeeded in expressing the mysterious charm of womanhood and girlhood so well as Gainsborough, notably in such works as *Mrs Sheridan, Mrs Graham* and *Miss Haverfield.*

Turning to the lesser English artists, we find that John Hoppner and John Opie are little more than pale reflections of Reynolds; they follow humbly in the steps of the master, never thinking to strike out new paths of their own. After a long eclipse during the 19th century George Romney regained some fifty years ago a quite unjustified esteem. In his portraits the texture is meager and the color lifeless; they are society portraits in the worst sense of the term, that is to say, the artist relies far less on the painterly qualities of his compositions than on the physical beauty of his model and the gracefulness of her attitude. Sir Henry Raeburn, known as "the Scottish Reynolds," was a highly expert and forceful painter, but his over-emphatic contrasts of light and shade soon pall on us. Noteworthy in his output are some vigorous, boldly executed likenesses, *Lord Newton, Colonel Alastair Macdonell of Glengarry*, and some charming pictures of children, *William Ferguson of Kilrie* and *The Elphinstone Children.*

A place apart must be assigned to Johann Zoffany, an artist of German extraction, and to the Scotsman Allan Ramsay. Zoffany harked back to the tradition of the small group portrait, the 'conversation piece' of the 17th-century Dutch painters, and posed his models in elegant interiors or rustic settings. Ramsay, perhaps because his art is so discreet, has not yet been given the recognition he deserves. Beside the subdued harmonies of his portraits, Raeburn's effects appear strident and Romney's

GEORGE STUBBS (1724-1806). A LADY AND GENTLEMAN IN A CARRIAGE, 1787. (32½ × 40″)
NATIONAL GALLERY, LONDON.
REPRODUCED BY COURTESY OF THE TRUSTEES

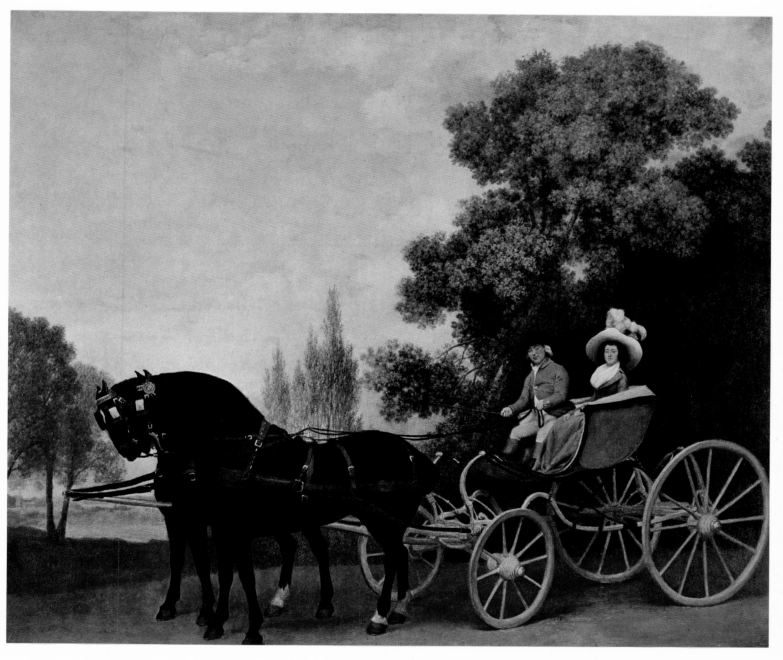

sadly superficial. In his color Ramsay broke free to some extent from the Van Dyck tradition, and played off delicate greys, faint pinks and muted blues against each other; indeed he was the most refined and independent colorist of the whole English school. His portraits—of his wife, of Countess Stanhope, of Lady Louisa Connolly and Caroline Lady Holland—have an intimate, engaging charm, reminiscent of Perronneau. While La Tour portrayed his models as they figured in society, emphasizing their wit or beauty, and Perronneau showed them in their moments of solitude, Ramsay, like Perronneau, sets out to show us men and women as they appear when they are not trying to shine in company or attract attention to themselves.

The last representative of this phase of British portraiture was Sir Thomas Lawrence whose career, from his start as a 'child prodigy' to his apotheosis as President of the Royal Academy, was one of unbroken success. A virtuoso of the brush, he turned out a vast number of portraits; in a good many of these, especially those of women, he tended to over-emphasize the aristocratic elegance of his sitters. "Lawrence," the poet Campbell shrewdly observed, "makes one seem to have got into a drawing-room in the mansions of the blest and to be looking at oneself in the mirrors." And certainly he pandered to the natural vanity of the great ladies who sat to him. Still there is much real charm in his *Miss Farren* and the portraits of *Lady Dover* and *Lady Leitrim*. However, it was in his portraits of men that Lawrence showed his talent at its splendid best, using his virtuosity for the expression of the model's personality. Such portraits as those of the infirm old Pope Pius VII, of Archduke Charles of Austria and Sir Walter Scott are far more than bravura pieces; they show real psychological insight and do credit to the English school of portraiture.

Yet are we really justified in lumping together all these portraitists in a 'school'? The term suggests a more or less cut-and-dried program and a community of ideas that the artists have thought up and put into practice. (It is in this sense that we speak of the Pre-Raphaelite and the Impressionist schools.) But when we survey the English portrait-painting of the 18th and early 19th centuries, from Lawrence and Reynolds to their rather clumsy provincial imitators, we find that (with the single exception of Ramsay) what distinguished these artists one from the other was the varying degree of their talents, not their approach to art; all of them, from start to finish, went through the same paces. In short, all aimed far more at meeting the wishes of their patrons than at implementing any artistic program and it is due to this persistent truckling to their clientèle that we cannot whole-heartedly commend their portraits, delightful as they are, and great as is the artists' skill.

There remains an artist difficult to classify; this is Georges Stubbs, who painted small family portraits, pictures of horses and rural scenes. He owed nothing to the painters stemming from the Flemish School, and still less to those little-remembered artists Benjamin West, John Copley and James Barry, who tried to inaugurate a school of British historical painting, nor yet to the pre-Romantics Fuseli and Blake. Stubbs knew nothing of Italy, nothing of Van Dyck; he went to school with nature and the Dutch little masters. Painstaking as Cuyp, naïvely realistic as Corot during his first

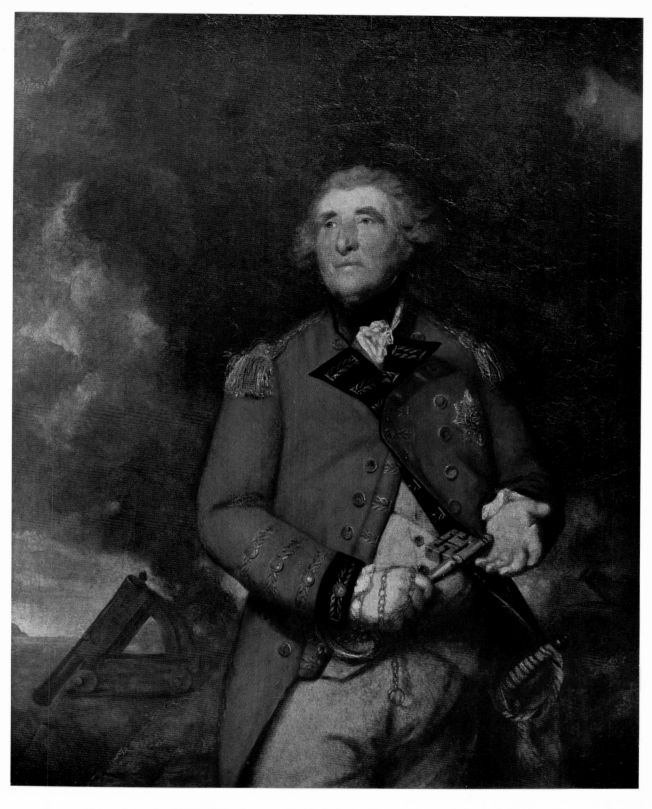

JOSHUA REYNOLDS (1723-1792). LORD HEATHFIELD, GOVERNOR OF GIBRALTAR, 1787. (56 × 44¾″) NATIONAL GALLERY, LONDON.
REPRODUCED BY COURTESY OF THE TRUSTEES

stay in Italy, he holds much the same place in the English painting of his day as Liotard in the French. He seems to have made a total, literal fidelity to appearance his ideal, with the result that some of his pictures have a superficial air of color photographs. But if Stubbs was ingenuous, he was ingenuous in the same way as the Douanier Rousseau, and likewise a painter born, and his art *au fond* is far from being merely photographic. He has an amazingly accurate sense of light and values, the picture surface is flawless, tones are subtly indicated; indeed we have here just the kind of painting that would have delighted Vermeer, Corot and Degas.

HUMANITY OF CHARDIN
AND THE SIMPLIFICATION OF FORMS

VERY *different from the gay world of* Fêtes galantes *and the Italian comedy, of festivals and merrymaking, is the world that Chardin shows us: that of the French middle class. Louis Le Nain had illustrated the simple lives of the peasantry: following in his footsteps, Chardin did the same for the city dwellers, not the élite but people of moderate means and sober habits. While his handling of his pigment and colors reminds us of Corot, his conception of the picture as essentially a problem of tones and volumes anticipates the discoveries of Cézanne. The Cubists studied with much interest* The Attributes of Music, *and Matisse copied* The Skate *with an eye to eliciting the secrets of the 18th-century master. Thus, of all the leading artists of the century, it was Chardin who most clearly pointed the way to modern painting. Like Chardin, Liotard, who hailed from Geneva, broke with the then fashionable practice of depicting life only under its rosiest aspects. In his eighties he took to painting still lifes; remarkable for the extreme delicacy of their execution and the simple, almost naïve directness of the artist's vision, these were quite different from all the other still lifes that were being produced in Europe during the period.*

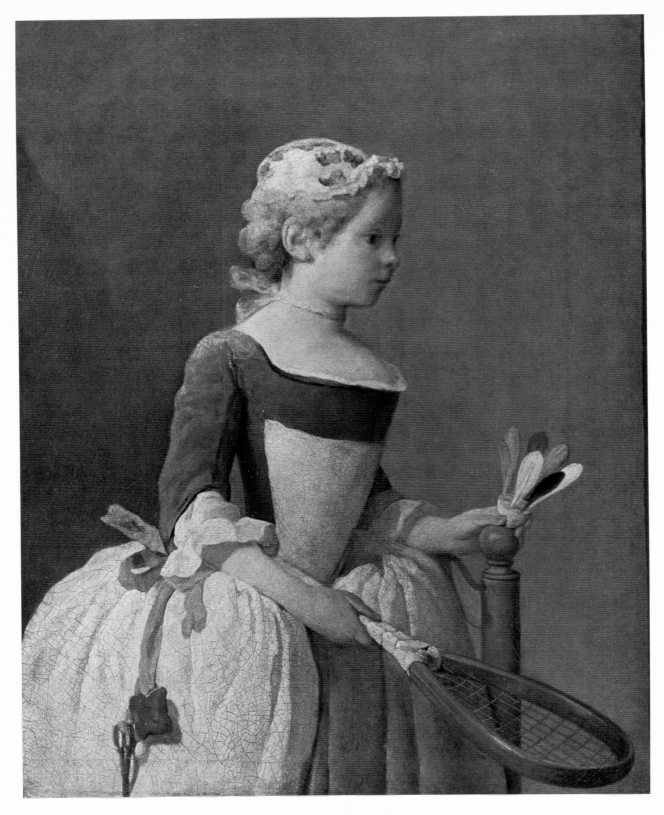

JEAN-BAPTISTE SIMÉON CHARDIN (1699-1779). GIRL WITH A SHUTTLECOCK, 1741. (32 × 25″)
PRIVATE COLLECTION, PARIS.

CHARDIN

For a long time Chardin was always presented under a rosy light, as being a modest, tolerant, hard-working man, endowed with every virtue, who died in straitened circumstances after a life of disinterested toil. Actually this flattering estimate of his character was a far cry from the truth, as we learn from Georges Wildenstein's valuable, copiously documented study of this painter. The truth of the matter is that Chardin was rather lazy, touchy, choleric and a bourgeois at heart. He kept a shrewd eye on his finances and saw to it that he had a regular income of some five or six thousand francs in his old age. The inventory drawn up after his death shows that his home was equipped with all the conveniences of the day.

His student period was short and the reason why he took to painting still lifes, then considered an inferior genre, was that there was a ready market for them.

Much research-work has gone to the tracing of Chardin's 'origins,' that is to say, the painters, French and foreign, who had painted still lifes or bourgeois interiors before him. I do not suggest that this research-work has been so much labor lost, but the problem is, after all, only of secondary interest. What particularly matters, in Chardin's case, is not that others dealt with similar subjects before him, but that, when he tackled them himself, he made proof of thorough-going originality and employed a unique, entirely personal idiom.

Let us briefly compare Chardin's works with those of the 17th-century Dutch little masters, often assumed to have been his forbears. Obviously the subjects are much the same: still lifes of articles of daily use, kitchen utensils, bottles, game, fruit and so forth, and interiors in which people are busy with household tasks, paring vegetables, giving the children their meals, making sketches or building card castles.

Why then are Chardin's canvases so vastly superior to those of Jan Steen, Metsu or Terborch? For the same reasons that Vermeer's are superior to those of his contemporaries: simply because Chardin, like Vermeer, had a truer sense of painting than the artists named above and also a way of handling his pigment all his own.

In Chardin's pictures the volumes are fuller, more broadly treated, than those of the Dutch painters, his color is juicier and more diversified, tones more subtly rendered. While never lapsing into wooliness, Chardin avoided the tedious precision of the Dutch *petits maîtres* with their meticulous attention to detail and harsh literalism. The objects he paints are bathed in light, the transitions between tones are never abrupt; thus the reflections from, say, a glass jug to a silver bowl establish links between them. In short the flawless over-all unity of his pictures is due to a perfectly balanced distribution of light and the harmony of the tones between themselves.

At first sight, a Chardin still life is apt to give an impression that the painter's only concern was to represent faithfully what he saw before him. Actually, however, he was one of the most skillful and subtle colorists the world has known and gifted, moreover, with a rare ability for rendering effects of texture.

For anyone with an eye sensitive to the material qualities and tactile values of a painting, it is a sheer delight to linger on those luscious, creamy whites, devoid of the least suggestion of chalkiness, which he employed for the earthenware jug and clay pipes in his still life at the Louvre and in the linen and pinafore of his *Little Girl with Cherries*; those tender pinks he uses for his flesh tones and for certain fabrics, and the delicate grey shadows of the half-glimpsed figure in the background of his *Housewife*. When he thought it called for, Chardin was quite prepared, on occasion, to step up his color to its maximum intensity; as in the deep russets of a violin or vivid carmines of a bowl of strawberries. In order to get just the color harmonies and exquisite textures he wanted, he relied on a wholly personal technique which certainly necessitated very many hours of patient toil. In a letter from Berch to the Swedish connoisseur, the Count of Tessin, written on October 17, 1745, mention is made of Chardin's "slowness." "One of the pictures he is working on now will probably keep him busy for another couple of months." Diderot described his technique as follows: "He applies his colors one after the other, almost without mixing them, with the result that his pictures remind one of marquetry work or a tapestry made with the *point carré* stitch." It was by boldly juxtaposing his colors and hardly blending them at all that Chardin achieved that shimmering, variegated texture which enables the light to circulate freely, makes shadows translucent, and kindles sudden gleams on the side of a coffee-pot, a dusty bottle-neck, or a copper cauldron.

"What a vain thing is painting, which calls forth admiration for the simulacra of objects whose originals are in no wise admirable!" Thus Pascal; and indeed our first reaction is to think "How true!"—especially in the case of pictures depicting common, not to say ugly kitchen utensils; it strikes us as almost preposterous that painters of such objects should be qualified as "great."

Many efforts have been made to explain just where Pascal was wrong; and perhaps the present writer may be allowed to add his word. The painter, whether he paints a figure, a landscape or a still life, reveals to us the essentially plastic values—form, color, texture—of his model, beauties which our indifference or ignorance prevents us from perceiving. Thus what the artist does is to enable us, once we have seen his work, to discover for ourselves these very real beauties every time we set eyes on the things he used as models. For the great majority of people an apple and a breakfast-roll are merely appetizing objects. But, by translating them into the specific language of painting, a language so rich in intimations, Chardin makes us realize that the apple and the roll are not only appetizing, but also things of beauty. "Before seeing Chardin's pictures," wrote Marcel Proust in a letter to Walter Berry, "I never realized how much beauty there was around me in my parents' home, in the half-cleared table, the lifted corner of a tablecloth, a knife beside an empty oyster-shell."

"There are some people," La Rochefoucauld rather scornfully observes, "who would never have fallen in love at all if they had not heard talk of love." In the same way, how many people there are who would have failed to see the beauties lavished upon us by Creation, had it not been for the painters!

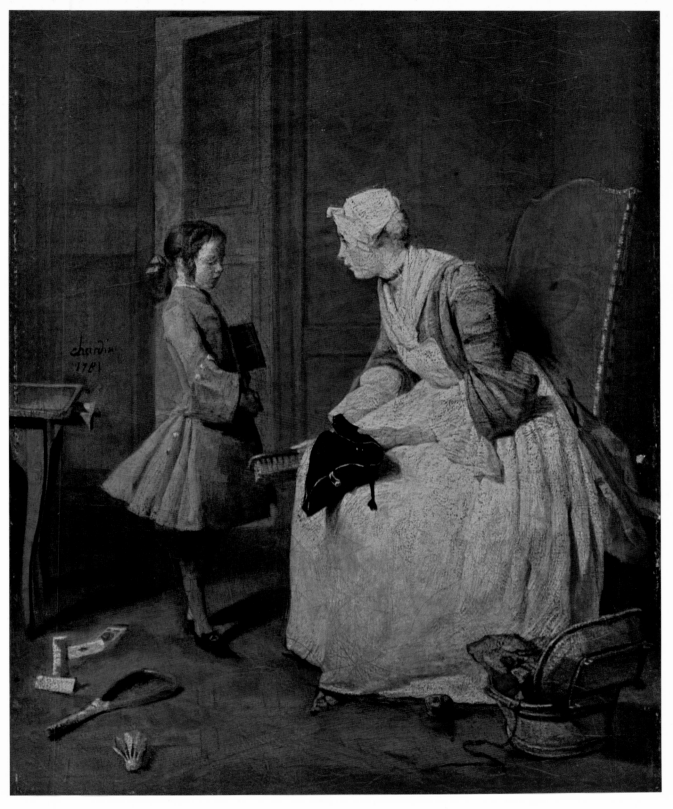

JEAN-BAPTISTE SIMÉON CHARDIN (1699-1779). THE MOTHER'S ADVICE, 1739. (17½ × 14″)
COLLECTION OF THE PRINCE OF LIECHTENSTEIN.

One day, when Chardin was in the company of his colleague and friend, the painter Aved, a lady called and asked the latter to paint her portrait, offering a fee of four hundred francs. Aved, who considered this sum inadequate, refused. After the lady had gone, Chardin remonstrated with his friend for rejecting such a windfall; being accustomed to receiving the most modest remuneration for his still lifes, he felt that four hundred francs was a far from despicable sum. "Yes," replied Aved, "but it's so much easier to paint a sausage than a portrait." Chardin was stung to the quick. He took the remark less as a joke than a statement of fact; and might not there be a very real danger that in the long run the public would grow tired of his still lifes?

Thus it is perhaps to a casual remark made by a friend that we owe Chardin's paintings with figures. Whether this anecdote be true or not—and it very probably is—or whether Chardin was tired of confining himself to the field of the still life and desirous of proving that he could shine in a more exalted sphere of art, the fact remains that, after making his name as a painter of inanimate objects, he showed himself

JEAN-BAPTISTE SIMÉON CHARDIN (1699-1779). THE ATTRIBUTES OF MUSIC, 1765. (36 × 57″)
LOUVRE, PARIS.

JEAN-BAPTISTE SIMÉON CHARDIN (1699-1779). CLAY PIPES AND EARTHENWARE JUG. (12 ½ × 16 ½ ")
LOUVRE, PARIS.

to be a no less admirable painter of genre scenes. All the qualities that make his still lifes so delightful are equally present in his pictures of women going about their household tasks and of children amusing themselves and playing games. He did not have to look far afield for his subjects; he had them under his eyes at every waking moment: servants, housewives, little girls, young people.

In turning to such subjects, Chardin did not try to represent them as participants in a lively scene, and in movement; his preference still went to what is stable and unmoving. The figures in these paintings are no less motionless than the saucepans or peaches in his still lifes.

JEAN-BAPTISTE SIMÉON CHARDIN (1699-1779). HARE WITH COPPER CAULDRON, CA. 1741. (26 ½ × 22″)
NATIONAL MUSEUM, STOCKHOLM.

Nor did he aim at clever effects in his arrangement of a scene, for, although his century ranked wit so high that a single brilliant remark could make a man's reputation for life, it was a quality in which Chardin was completely deficient. His figures are placed in perfectly natural attitudes without the least concern for the effect they may produce on a spectator.

Did Chardin deliberately turn his back on the fashionable, sophisticated painting of the day in order to extol the sober, placid virtues of the middle class? Many have taken this view and much ink has been spilt in promulgating it. Chardin has even been presented to us as a democrat, a precursor of 1789. If I may, I should like to dissent from an opinion for which there is not the least foundation and which ignores the fact that Chardin was primarily a painter, and indeed nothing but a painter.

When Chardin decided to turn his hand to a genre other than the still life, he realized that his lack of imagination and his limited artistic training debarred him from tackling mythological subjects and *fêtes galantes* in the manner of his contemporaries. He was never sure of himself unless he could paint from a model before his eyes; this was one of the reasons of his predilection for the still life. For painters like Chardin or Cézanne, who love to linger over the same canvas, working over it again and again and gradually perfecting the texture, the still life is the ideal subject. The objects composing a painting of this type remain unmoving and unchanged day after day, whereas in a landscape the light is always changing and the scene varies from one hour to another. Did not Cézanne, when he set out to paint a bouquet, fall back on artificial flowers, and had not Diderot pointed out this very fact in his *Salon* (1765)? "It is true that these objects do not change under the artist's eye; as he saw them for the first time, so they remain day after day." I should not be at all surprised to learn that Diderot was merely repeating a remark made to him by Chardin himself.

The still life has yet another advantage for the artist, and of a rather special kind: it sets him only those problems which are basic to painting and rules out the others, such as the plastic interpretation of a subject, psychological analysis and expression, or the creation of a poetic world. With his field thus narrowed down, the artist can concentrate on essentials, namely form and color.

This Chardin did, and it is why he was able to produce masterpieces in a genre usually considered secondary. He does not seek to enlist our sympathies or to rouse our emotions, or to portray any world other than the one in which we live. In painting what he saw before him, he did not attempt, like Degas and Lautrec, to play the keen-eyed observer who depicts the mores and types of his period without fear or favor. He was simply a painter, and had no ambition to be anything else. An academic painter, whose name I have forgotten, thus expressed his indignation when someone voiced his approval of Corot's figures: "Why, the man paints a woman's bosom in exactly the same way as he would paint a milk-can!" Notwithstanding all the stories we have been told about Chardin's love of home-life and the way in which it inspired his art, he painted housewives and children in exactly the same manner as he painted kitchen utensils and fruit. On an earlier page, I mentioned Vermeer's name and I have also

had occasion to mention that of Corot. Vermeer, Chardin, Corot: artistically speaking, all three belong to the same family.

The Goncourts' book on 18th-century art contains an ingenious comment on Chardin's handling of color: "To paint everything in its *real* tone without painting anything in its *own* tone: such was the *tour de force*, not to say the miracle, brought off by this great colorist."

JEAN-BAPTISTE SIMÉON CHARDIN (1699-1779). DESSERT, 1763. (18½ × 22″) LOUVRE, PARIS.

A singularly apt definition—and one which might be applied with equal justice to the methods followed by the Impressionists more than a century later. Does not "to paint everything in its real tone, without painting anything in its own tone" exactly describe their program? In other words, when painting an object, they employed the color in which they saw it clad, rather than the color which they knew it to possess. When Claude Monet detected blue reflections in a highly polished parquet floor and transferred them to canvas, he was only putting Chardin's method into practice, though with a difference: his passion for color led him to exaggerate his visual response.

Although he represented scenes from everyday life, Chardin—unlike so many Dutch painters—always eschewed the anecdotal. We must not be misled by the titles of such pictures as *The Hard-working Mother* or *A Lady and her Amusements*; these were only concessions to the practice of his day. Another proof that he had not any intention of being a painter of contemporary manners is that he so seldom attempted to vary his subjects. Like Cézanne he was a painter pure and simple.

When in his seventies Chardin exhibited his first pastels, and he continued painting in this medium till his death. Abandoning still life and genre pieces, he now devoted himself to portraits and studies of heads. Some have said that this change of medium was due to failing eyesight. The same theory has been put forward for Degas' switch-over from oils to pastels in his old age; but in my opinion, it is unfounded. Once an artist's sight begins to play him false, he finds it quite as hard to place his 'touches' accurately with a crayon as with a brush. No, the true reason for this change of technique must be sought elsewhere. We know that Chardin always spent a long time over each canvas, and once his health began to fail (he was suffering from a gall-stone) he must have found that this long drawn-out procedure over-taxed his strength. This explains why he took to using pastels, which enabled him to work much faster and indeed necessitated rapid execution.

The procedure which he followed in his oil painting—of juxtaposing touches of different colors without blending them together—and which so much startled his contemporaries, is less apparent today; since the pigment has become more transparent with the years, the separate touches seem to merge into each other. But in his pastels, the touches remain distinct, exactly as they came from Chardin's hand. He did not smoothe them with the tips of his fingers (as was done by some pastellists) but applied them firmly and crisply, with the result that, contrasting with each other, they cause the whole picture surface to vibrate with scintillating color. On a close-up view of a Chardin pastel we find that it is a pattern of color-stripes or 'hatchings,' while at a distance we seem to have the living flesh of a face before our eyes. As the Goncourts remark in their *Art of the Eighteenth Century*, "Chardin renders admirably the blotches on a cheek, the bluish tint imparted to a chin by a day's growth of beard, no less than the delicate bloom, the pinks and whites of a young face. With little streaks of pure blue, vivid red and golden yellow he builds up a complexion giving the perfect illusion of life." Chardin's procedure was taken over a century later by Degas in his wonderful pastels, and to the happiest effect.

JEAN-ÉTIENNE LIOTARD (1702-1789). STILL LIFE, 1783. PASTEL. (12 × 14″)
SALMANOWITZ COLLECTION, GENEVA.

One of the reasons why we place this still life, with its subtle color and ingenuous emotion, immediately after Chardin's is that it seems of interest to present in this context a work which, in respect of both the artist's vision and his execution, totally differs from what was then being produced in this genre. When, near the end of his long career, Liotard took to painting still lifes, he did not trouble to observe accepted rules or to achieve a skillfully balanced composition. He merely put some apples on an ordinary dish, then placed it on a deal table, and brought to painting these simple objects the naïve sincerity of a Primitive, bent solely on making his rendering of his subject as faithful as he could.

EIGHTEENTH-CENTURY MAN

LA TOUR · PERRONNEAU · NATTIER
LIOTARD

THOUGH *on certain occasions Nattier ventured to disregard the conventions of the day and to paint such charming pictures as the one we reproduce (in which we seem to have a foretaste of Ingres' famous 'Odalisques') the fact remains that all too many 18th-century portraits are deliberately flattering and one feels that the artist's wish to gratify his sitter has prevented him from creating a true work of art. Happily, however, some artists applied themselves to depicting the men and women of the day as they really were and not as they wished to appear in others' eyes. Indeed an eminently rational and philosophic-minded century like the 18th could hardly fail to engender works giving a true impression of individual personalities. Moreover, such was the psychological insight displayed by artists of the caliber of Liotard, Perronneau and La Tour that their influence made itself strongly felt in the portrait-painting of the following century.*

EIGHTEENTH-CENTURY MAN

Largillierre, who was born in 1656 and died in 1746 at the age of ninety, belonged as much to the 17th century as to the 18th, and the same is true of his art. While many of his portraits have something of 17th-century pomposity and staidness, others already strike that freer, livelier note characteristic of the new century: for example, his *Belle Strasbourgeoise*, his *Elisabeth de Beauharnais* (Museum of Grenoble) and the large canvas in the Louvre showing the artist himself with his wife and daughter before a landscape background. An enthusiastic votary of Rubens and Van Dyck (he had studied at Antwerp and London), Largillierre took obvious delight in rendering the delicate bloom of cheeks, the sheen of silks and satins. But in his color he keeps to that of the great Flemings, with the result that his pictures strike us as relatively somber as compared with the brighter painting of such men as Boucher and Coypel.

An artist who excellently typifies the style of portraiture favored by the 18th century is Louis Tocqué. In a lecture delivered at the Academy in 1750, he voiced what we may take as the then current opinion of what a portrait should be: "A woman, though neither beautiful nor even pretty, usually has moments that show her in a favorable light. Her face gains or loses charm according to her mood. It is for the painter to seize on those happy moments which seem to impart to her a certain beauty." It was, in fact, just those "happy moments" that the portrait-painter made it his aim to register during that bygone age when society life was regarded as the finest flower of culture. Tocqué himself painted a number of 'society portraits'—for example, his portrait of Marie Leczinska (in the Louvre) and that of the Marquis de Marigny (in the Museum of Versailles)—with all the polite attenuations of the truth that this branch of painting called for. In them he displayed much skill in rendering rich damasks woven with gold and silver and velvets spangled with fleurs-de-lis, and in making the draperies of his backgrounds ripple in graceful folds. In this respect he followed in the footsteps of Largillierre, from whom he may have also derived his feeling for reality; for though he favored those ideal moments which show a face at its best, he did not attempt to make handsome women out of plain ones. Thus in his *Portrait of Madame Harant* (Collection of the Marquis de Jaucourt), with her bulbous nose and over-large mouth, we realize that he is only doing the best he honestly can by a woman with whom nature has dealt unkindly. When fortune favored him and his sitter was an attractive young girl like Mademoiselle de Coislin, the portrait in the Yznaga Collection shows how well he could capture the bloom of youth, the charm of innocence, the grace of a white bosom framed in a damask bodice trimmed with flowers.

Tocqué's teacher and father-in-law was Nattier, as to whom it must be admitted that he lacked both the integrity and the scrupulousness of his pupil. His face as shown in La Tour's portrait has a curious foxiness and conveys an impression of insincerity. We picture him deliberately setting out to win his public and make good at any cost. And so he did, enjoying great vogue at the French Court where for many years he turned

JEAN-BAPTISTE PERRONNEAU (1715-1783). PORTRAIT OF CHARLES LENORMANT DU COUDRAY, 1766.
(24¼ × 19″) MUSÉE COGNACQ-JAY, PARIS.

out smoothly executed portraits of princesses and ladies dressed up as Olympian goddesses. This was flattering for his models and at the same time provided them with an opportunity of posing in the near-nude without giving offence. They were in good hands, for Nattier could embellish a breast, a leg, a face with unfailing skill. Thus he was showered with commissions and made large sums of money. To the modern eye, however, his slick, standardized beauties have little appeal; indeed they all look so much alike, staring at the spectator with the same languorous, would-be alluring gaze, that they soon get on our nerves. We feel all the more annoyed with Nattier for thus pandering to the taste of his patrons as he clearly had the makings of a very fine painter: witness his portraits of the daughters of Louis XV, the portrait of his own daughter, and that of a woman painter (in the Museum of Besançon).

Come from Sweden to seek his fortune in Paris, Roslin was a second Nattier, but an inferior one. He beautified his models to an even greater extent, and was less painterly about it. He was no less admired for his skill—quite superficial, be it said—in rendering the play of light on satins and watered silks than for his knack of imparting the bloom of youth to women whose beauty had faded with the years. In a century when to be agreeable was the order of the day and a well-turned compliment or a cleverly rhymed madrigal could make a man's fortune, it was only natural that such artists as Nattier and Roslin should have been the pets of a society they flattered to the top of its bent.

With Aved we come to a painter of a different caliber. He was a native of

JEAN-MARC NATTIER (1685-1766). MADEMOISELLE DE CLERMONT AT THE BATH, 1733. (42 × 40½") FROM THE ORIGINAL IN THE WALLACE COLLECTION, LONDON, BY PERMISSION.

70

JEAN-ÉTIENNE LIOTARD
(1702-1789). PORTRAIT OF THE
COUNTESS OF COVENTRY, CA. 1749.
PASTEL. (9 × 7½″) MUSÉE D'ART
ET D'HISTOIRE, GENEVA.

Douai, in Flanders, and it was not for nothing that he spent his youth in the Low Countries. Looking at his forthright, colorful portraits, we feel that he had studied the Dutch and Flemish masters with a discerning eye; indeed, he owned eight pictures by Rembrandt. A friend of Chardin, he sat as the model for *The Alchemist*, now at the Louvre. One of Aved's finest works, in fact—the *Portrait of Madame Antoine Crozat, Marquise du Châtel, at her Loom* (Museum of Montpellier)—long passed for being Chardin's portrait of Madame Geoffrin. Aved painted other noteworthy portraits, such as the one in the Louvre showing Victor Riquetti, Marquis de Mirabeau, in his library. Not only is this a fine piece of painting, it is also a typical picture of the intellectual aristocrat of the 18th century; we feel the Marquis is on the point of expounding his views on Man, Society and the world at large to some interested caller.

After Aved we may turn to Duplessis, who belongs to the second half of the century. This is apparent in his portraits, in which remains no trace of the 'grand manner' that Nattier and Tocqué had inherited from Largillierre. These are glimpses of the model in his unguarded moments, when he is not out to make an impression, but reveals himself as the man he is in private life, not in the public eye. Of this order is the portrait of

the painter and sculptor Joseph Péru (Museum of Carpentras), with his dry, withered features, tight-set lips and disillusioned gaze. In his portrait of Gluck (Kunsthistorisches Museum, Vienna) Duplessis shows us the musician improvising at the harpsichord, lost in an inner dream, indifferent to his surroundings. Without lapsing into romanticism the artist has brought off a truthful and revealing picture of a composer in the grip of inspiration. Yet, perhaps it is the *Portrait of Madame Lenoir, née Adam* (Louvre) that should rank as Duplessis' masterpiece. With its taut drawing, the harmony and aptness of its color-scheme, this canvas is a marvelously convincing picture of a young middle-class Frenchwoman of the late 18th century. In her hands she holds a book with mottled paper covers, and we feel she is open to the new ideas of the time, eager to improve her mind. Though she is not precisely a beautiful woman, her alert gaze and the faint smile flickering on her lips tell of intelligence and a sense of humor. Penetration, sincerity, naturalness, a technique highly skillful but untouched by any straining after cheap effect—such are the distinguishing features of this fine portrait by Duplessis. And indeed, throughout the centuries, are not these qualities the hallmark of good French portraiture?

There is a world of difference between such a painter as Liotard and those other artists who, merely to satisfy the whims of a public eager for novelty, took to making the portraits of lords and ladies attired in oriental costumes. Liotard had actually spent several years at Constantinople, so that when he painted a model dressed *à la turque*, he did so with scrupulous accuracy. In the picture by Nattier here reproduced— obviously influenced by Veronese, and in which, incidentally, he shows himself more painterly than usual—the artist has made a Sultana out of Mademoiselle de Clermont, just as he had made Olympian goddesses out of the ladies of the Court. Obviously his concern was less to be truthful than to be picturesque.

Liotard, on the other hand, as we see here, has dressed his model in an authentically oriental costume and placed her in an interior of the kind he must have often seen at Constantinople: a room with bare walls, containing only a small divan and a carpet. This portrait is traditionally supposed to represent Mary Gunning, Countess of Coventry. But there are reasons for doubt. My opinion is that we have here not the beautiful Englishwoman, but Mimica, the Greek girl with whom Liotard fell in love when he was at Constantinople and whom he was on the point of marrying. However, to state my reasons for this view would take me too far afield. In any case, this pastel has not only singular charm and grace, but solid qualities that entitle it to rank high in the painting of the period: fine precision and finish, an exquisite feeling for color, originality of composition and a flawless sense of values. We should have to go far indeed to find other pastels comparable to it; probably the only others are Degas' pictures of dancers done round about 1875.

The two outstanding 18th-century French portrait-painters in pastels were Perronneau and La Tour. During his lifetime the latter enjoyed more success than his rival because he possessed in a high degree qualities much sought after by the public of the day: impeccable draftsmanship and a knack of making his portraits seem 'alive.'

It may be, too, that La Tour's personality as a man caught the fancy of a society eager above all to be amused, for he was a free-and-easy, impudent, not to say bumptious individual with a glib but entertaining tongue. For the last fifty years or so, however, by reason of his exceptional gifts as a colorist, Perronneau has had the preference of art-lovers increasingly sensitive to the fascinations of color. The Goncourts were the first to draw attention to this aspect of Perronneau's art.

La Tour's portraits fall naturally into two classes: the finished ones that he delivered to his sitters, and the preliminary studies he made from life, sketching out the features of his sitter on grey-blue or yellow paper. Some of the finished portraits are very fine—when the artist had the sense to stop in time. Others give an impression of heaviness; the color lacks warmth and spontaneity. The truth is that La Tour ruined many a good portrait by excessive retouchings, by straining to achieve in pastel a vigor that only oils can implement. His contemporaries were not blind to this defect. "He never knows how to stop at the right moment," said Bachaumont, author of *Les Mémoires secrets*. "He is always trying to improve on what he has done, with the result that, by dint of working over and tinkering with his picture, he often spoils it. This is a great mistake: pastel must never be worked over in that way. Too much working-over tends to rub off its delicate bloom and the surface is dulled."

Thus, in La Tour's output, it is the preliminary studies that show him at his best; for instance the group of these bequeathed by the artist to Saint-Quentin, his native town. Indeed we cannot evaluate his talent unless we see this fine anthology of the faces of noblemen, great ladies, magistrates, actors, actresses, financiers, clergymen, writers and artists. Here, for example, is Monsieur de Julienne, Watteau's friend, trying to conceal his weariness of life with a sophisticated smile; here we have the massive features of Crébillon *père*, the witty regard of Madame Camargo, the artless, rosebud charm of Mademoiselle Puvigné; and finally the artist himself with an ironical curl of the lip, flashing a shrewd glance at us.

We have no compunction in quoting once more from the Goncourts' *Art du dix-huitième siècle*, that rich mine of information for the student of 18th-century art. Referring to La Tour's portrait studies in the Saint-Quentin Museum they write: "How amazing is this pageant of the life and the climate of a bygone social order! No sooner do you enter the room than an uncanny feeling comes over you, unlike that produced by any painting of the past: all those heads seem turned in your direction, all eyes are fixed on you, and you feel that all those mouths have only just fallen silent; that the 18th century was engaged in conversation, and you are an intruder!"

This is well said. All the same, while giving an excellent idea of the impression this collection makes, the Goncourts—probably without realizing it—have touched on the vital flaw in La Tour's art. For he shows us his models only as they appear in society, in others' company, when the thought of the effect they are producing on those around them is uppermost. Thus he was the ideal painter of a social order for which the give-and-take of witty conversation counted for so much. Never does La Tour show us a man in those moments when he is alone, truly himself; not as he

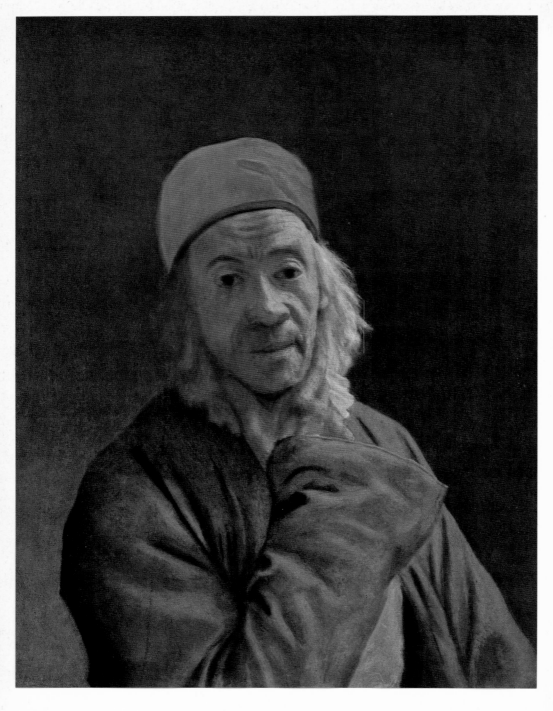

JEAN-ÉTIENNE LIOTARD (1702-1789). PORTRAIT OF THE ARTIST. PASTEL. ($24\frac{1}{2} \times 20\frac{1}{2}''$) MUSÉE D'ART ET D'HISTOIRE, GENEVA.

would wish to appear in others' eyes. Confined to the oval of the face, his studies render no more of the human head than its outer aspects, that mask in fact, which a man is so ready to assume amongst people whom he wishes to impress or charm. It was not La Tour, but Perronneau who should have been commissioned to make the portrait of Jean-Jacques Rousseau, that man who was so hopelessly ill at ease in the society of others and at his best only when alone.

That indeed is the special merit of Perronneau's portraits, and what strikes us most about them is that they are far truer to life, more human and sincere than La Tour's; they show us men as they really are, when free of the constraints imposed on them by social life.

Perronneau imparts poetic overtones to some of his likenesses, especially to those of young people. It has been said that "many of Perronneau's portraits seem to have been painted while the model was listening to music," and there is much truth in this. Whereas the accompaniment to a portrait by La Tour is the hum of lively conversation, a quick-fire of sally and repartee, the musical background to many a one of Perronneau's portraits is a soft melody, welling up from depths of silence, that evokes in the eyes of his model a gleam, at it were, of his secret dreams.

It well may be that the poetic quality we find in some of Perronneau's portraits is largely due to the delicacy and originality of his color. La Tour cannot really be called a colorist; nor (unlike Liotard) does he make any effort to render faithfully the light enveloping his model. He concentrates on that accurate drawing which ensures a telling likeness and a convincingly lifelike expression of the face; for he wants his portraits above all to seem 'alive,' to make us feel that at any moment they might engage us in conversation. As regards his color, La Tour tends to work by rule-of-thumb; he almost always employs the same tonal relations in rendering flesh-tints, laces, and powdered wigs.

Not so Perronneau, who, considering the age he lived in, strikes us as an audacious colorist. Thus, for example, in a face he does not hesitate to play off blue or green shadows against pink highlights touched with gold. He has a predilection for subtle, carefully devised relations of tones that bring out the textures of satins, velvet, and silk. Although the Goncourts did not devote a separate chapter to him in their *Art du dix-huitième siècle*, they were well aware of his high qualities and stressed his fine sense of color. In the chapter on La Tour, after eulogizing one of Perronneau's portraits, they conclude: "Perronneau is a better colorist than La Tour."

MAURICE QUENTIN DE LA TOUR (1704-1788). PORTRAIT OF THE ARTIST, 1751. (22 × 17 ½ ") LOUVRE, PARIS.

In *La Maison d'un Artiste*, describing the works of art he and his brother had collected, Edmond de Goncourt makes the same point. "Perronneau, a great pastellist unjustly passed over by Diderot in favor of La Tour... More than La Tour, he was a natural colorist, his paintings sparkle with finely granulated color, the tones are bright and limpid as morning dew."

His skill was not confined to crayons; Perronneau proved himself no less expert when he had recourse to oil-paints and brushes, as is evident in such works as *Oudry*, *Adam the Elder*, and *La Duchesse d'Ayen*, in which he succeeds in imparting interest to the most unrewarding of faces, and in his *Madame de Sorquainville*, where the exquisite harmony of dim blues and straw-yellows bespeaks the colorist born.

Thus three men, Perronneau, Liotard and La Tour stood for three different conceptions of the portrait, each of which was valid, since each artist solved the problem set by the psychological portrait in his own way. As for the society portrait, the task it set the painter was relatively simple; all he had to do was to see to it that his likeness of the sitter was as flattering as he could make it; a likeness stressing whatever desirable qualities the sitter actually had, or thought to have, or anyhow would like to have: beauty and charm in the case of a woman, manliness and gallantry in that of a soldier, dignity and the habit of command in that of a monarch. The psychological portrait, however, made greater demands on the artist; by his handling of the lines, volumes and tones of his sitter's face he had to express the man within. Does it follow that the portrait-painter has to be an expert psychologist? I doubt if this is needed; all he needs is to be greatly talented. Few portraits are so revealing as those by Ingres, yet Ingres himself was far too temperamental and self-centered to be perspicacious. When we examine the self-portraits made by Liotard and La Tour towards the close of their lives, we see that they aimed solely at faithful likenesses; at representing their faces as they were after the years had wrought their havoc on them. Yet what written description could be so telling, so character-revealing as these likenesses? In Liotard we see a man who has shrewdly observed the world and enjoyed to the full all the pleasures it can offer; who, despite the onset of old age, keeps his eyes open and his mind alert, and can be counted on to make the best of the brief span of life remaining to him. La Tour is no longer the gay spark of his young days, that look of bland impertinence which characterized the portraits of his years of triumph has quite disappeared; we only see a very tired old man. The vague smile playing on his lips is curious; is it, one wonders, put on for the spectator's benefit? Or is it a premonitory symptom of the mental breakdown which was to turn, in his last years, this erstwhile adulated artist into a pathetic, maudlin, slightly repulsive dotard?

SECOND PART

FESTIVALS OF THE IMAGINATION
AND ITALIAN GRACE

★

MYTHOLOGICAL THEMES
AND DECORATION

FRAGONARD AND LANDSCAPE

THE COLOR OF VENICE

THE LIGHT OF FRANCE
AND THE LIGHT OF ENGLAND

MYTHOLOGICAL THEMES AND DECORATION

TIEPOLO · BOUCHER

DURING *the 18th century the vogue for large-scale decorative paintings, religious and secular, which had begun with the Renaissance, spread throughout Europe, most conspicuously in France and Italy. In France commissions for work of this order went chiefly to Lemoyne, Natoire, the Coypels, the de Troys, the Vanloos and, above all, Boucher, who enjoyed immense success in his day and is still regarded by many as being the typical 18th-century artist* par excellence. *Such indeed was the prestige of his work that it cast into the shade that of such infinitely superior artists as Watteau, Chardin and Fragonard. (Curious and perhaps significant of 18th-century taste is the fact that so few decorative works were commissioned from these artists.) Nowadays we see in Boucher no more than a virtuoso of the brush who skillfully exploited the penchant of the nobility and clergy for a conventional, rather flashy type of art. In the decorative domain Boucher had a rival in Tiepolo who was perhaps one of the finest decorative painters the world has known. Gifted with an inexhaustible inventiveness and no less versatility, he explored many fields of art, outdoing Boucher and even Fragonard in this respect. He was equally successful in depicting the Carnival of Venice with its masquerades and public merrymaking and the exotic pomp and splendor of the 'Festivals of Cleopatra.' Moreover in an age wholly given up to the pursuit of pleasure he evoked with a poignancy unique for the period the tragic episodes of the Passion of Christ. Thus it is not surprising that Goya was much influenced by the art of Tiepolo.*

TIEPOLO AND BOUCHER

There are several reasons why the French 18th-century decorators, so popular in their day—Coypel, de Troy, Natoire, Vanloo, Lemoyne—mean so little to us now. For one thing, many of their works no longer exist, while others have been 'restored' out of recognition. But the chief reason for their oblivion is that these artists were deplorably lacking in originality; admirable technicians, they knew only that part of art which can be taught. Moreover, all drew their inspiration, such as it was, from the same sources, with the result that all their works are alike. They put nothing of their own personalities into their art. Who would suspect that the man who made the gay and gorgeous decorations in the Salon d'Hercule at Versailles, François Lemoyne, was a confirmed hypochondriac who committed suicide at the age of forty-nine? Or, looking at those tedious compositions in which Natoire depicts the goddesses of Greece with rouged cheeks and fashionably dressed hair, who could guess that this painter, consumed by ambition, was to lapse into the dreariest religious bigotry?

It is in the tapestries made to their design that we see these artists to best advantage. Only when their painting is transposed into the bright tonalities of tapestry does their very real skill as decorators become apparent.

In the contemporary Venetian school, besides landscapists and painters of the scenes of daily life, there were other artists whose tastes were primarily decorative. Reacting against the somberness and solemnity of so much 17th-century art, and its strong contrasts of light and shade, they sponsored a more cheerful type of painting, luminous and gaily colored. Superficial and derivative as is the art of such a man as Sebastiano Rizzi, he has a pleasant feeling for color. Giambattista Piazzetta, a more original artist, was particularly interested in volumes; his method was to lay in his pictures with a monochrome foundation in brick-red tones, then to float light glazes over it. The charm of his best-known work, *The Fortune-Teller*, is undeniable, and his ceiling picture in the Church of St John and St Paul in Venice *(The Triumph of St Dominic)* anticipates the achievements of Tiepolo, his junior.

The great master of 18th-century Venetian painting was unquestionably Giambattista Tiepolo. He decorated many churches and palaces at Venice, palaces at Milan, Verona, Würzburg and Madrid and churches at Bergamo and Milan. In these tasks he was often aided by his sons Giovanni Domenico and Lorenzo, and the wealth of pictorial inventiveness he lavished on these decorations was nothing short of prodigious. One has an impression that he regarded the whole universe as a vast repository of stage-properties ready to his hand, and the men and women around him as "merely players." All he wanted was to make "a feast for the eyes," as Delacroix put it and, unless the subject ruled this out, the mood of the picture was invariably joyous. There was nothing academic in his approach; the mere act of painting delighted him so much that he never troubled about the accepted canons of art. Likewise, he never let himself be curbed by the hard facts of archaeology and history; the picturesque—that

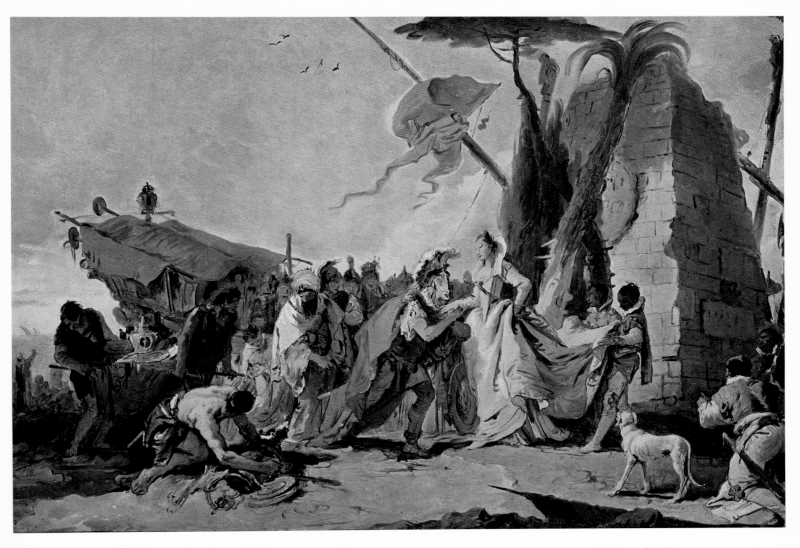

GIAMBATTISTA TIEPOLO (1696-1770). MEETING OF ANTONY AND CLEOPATRA, BEFORE 1747. (18½ × 26½")
PRIVATE COLLECTION, PARIS.

is to say the paintable—was all that mattered to him. Thus when his theme was taken from mythology or ancient history, while the heroes with their gold cuirasses and plumed helmets look like Roman proconsuls, the women wear damask farthingales and the high ruffs of 16th-century Venetian ladies. Mingled with them are Turks who might have stepped out of the *Arabian Nights*, Negroes in yellow or shrimp-red jerkins, bandy-legged dwarfs. Camels and elephants wind their stately way amongst pyramids and venerable landmarks, ivory-yellow, pink-nostrilled horses curvet above dove-colored clouds, while Time, a bearded ancient, his skin tanned dusky red, embraces a white, fair-haired Fortuna. In fact Tiepolo sees the great epochs of history as one vast carnival in which all ages, all the nations of the world, forgather indiscriminately —and time itself is an anachronism! All he wants is to delight our eyes with a gay concourse of enchanting forms and colors.

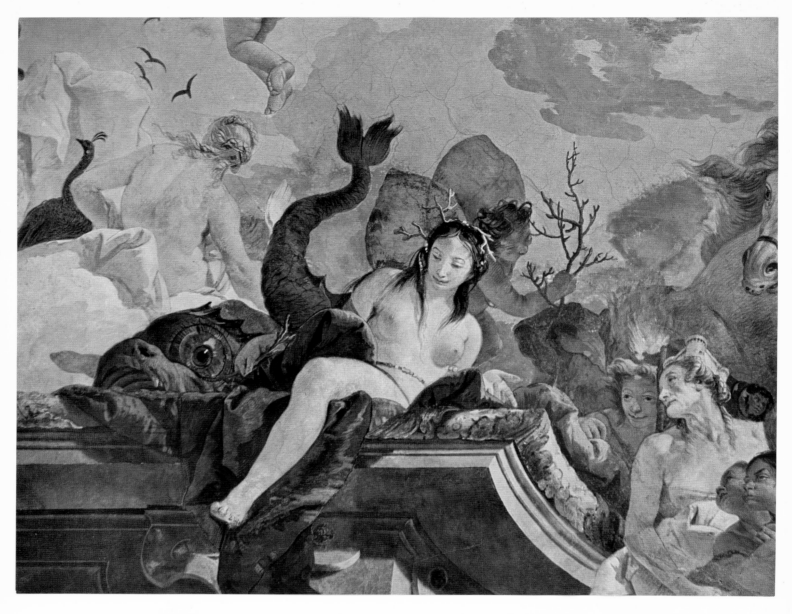

GIAMBATTISTA TIEPOLO (1696-1770). NYMPH AND DOLPHIN, 1740. FRESCO, DETAIL FROM THE CEILING. PALAZZO CLERICI, MILAN.

Yet, charming as is this art, the modern spectator, inured to a very different conception of painting, has to overcome several deeply ingrained prejudices, if he is to enjoy it unreservedly.

To begin with, we are disconcerted by the tiered perspective of his ceiling decorations; by those figures, floating in the sky which, seen from below, assume the most unlooked-for postures. Nowadays illusion-miracles are out of favor, virtuosity is at a discount; thus we tend to look askance at Tiepolo's achievement, prodigious though it is. Also, his way of handling sacred themes in his apse-paintings shocks many people and makes even the most indulgent feel ill at ease. "But what a peculiar way," they

protest, "of treating religious themes! True, it makes a wonderful ballet and those angels have the shapeliest legs one could wish for. Their only mistake is wanting to be angels. Surely, instead of parading his skill as a ceiling painter and playing on our senses, Tiepolo should have tried to conjure up pious thoughts in the beholder." Let us admit that these objections carry weight and that it costs us an effort to admit that, after all, these celestial frolics are not so very far removed from renderings by Giotto,

FRANÇOIS BOUCHER (1703-1770). THE TRIUMPH OF VENUS, 1748. (51 × 63 ½") NATIONAL MUSEUM, STOCKHOLM.

Fra Angelico and Rembrandt of similar themes. But it should also be admitted, in Tiepolo's favor, that the subjects treated by him in the domes of churches are Assumptions, Ascents into Heaven, Triumphs—in other words, joyful not sad occasions: *Te Deums* and *Alleluias*, not *Misereres*. Moreover, when the artist deals with subjects related to the Passion, as in his S. Alvise triptych at Venice, his treatment is both reverent and dignified. The same is true of the four canvases in Count Seilern's collection (London): especially the *Saint Pascal Baylon adoring the Holy Sacrament* and *San Carlo Borromeo meditating on the Crucifix*.

"Tiepolo is a witty man, obliging, zestful, with a gift for brilliant color, and an amazingly quick worker." Thus Count Tessin, Swedish plenipotentiary at Venice, reported in 1736 to his sovereign, Frederick I, who was thinking of commissioning a Venetian painter to decorate the new Royal Palace at Stockholm. "He paints a picture in less time," the Count added, "than another painter takes to grind his colors," and he was hardly exaggerating. Aided by his two sons, Tiepolo made the decorations of the vast Imperial Hall at Würzburg within six months.

Like Raphael and Tintoretto, Tiepolo had a remarkable gift for composition and for creating a happy balance of masses, of dark passages and highlights. Another of his gifts was that of suggesting movement by complementary or contrasting lines, while his adroit handling of perspective enabled him to render unusual and surprising attitudes.

His abilities as a colorist show to better effect in his frescos and small sketches than in his large altarpieces, in which the pigment often seems unduly thin. He treated the fresco on the lines of a watercolor done in opaque pigment, much white being mixed into many of the colors, the result being a texture whose chalkiness sometimes reminds us of painting in pastels. Against bright, strongly luminous tones he plays off red ochres, ivy-green and dull violets. Such is the sureness of his drawings that he fixes outlines and locates accents directly with his brush. His *facture* is terse, highly strung, elliptic. In his oil paintings the impasto is lavishly laid in and unctuous, while the colors have a rich, gemlike luster.

In Tiepolo's case as in Watteau's a prodigiously fertile imagination is seconded by close observation of reality. But in his work the elements borrowed from the real world are so skillfully amalgamated and transmuted that their presence often eludes the eye. Yet what a keen sense of reality is apparent in, for example, the dimples on the thighs and the full curves of the hips of his *Venus with the Mirror*! Similarly, the deliciously unconstrained posture of his *Danaë* (Stockholm) is obviously due to direct observation, and the same is true of the nymph crowned with coral in the decoration of the Palazzo Clerici at Milan, her pale beauty contrasting so happily with the dark bulk of the sea-monster. From his early days Tiepolo made no secret of his predilection for the female nude. We see this also in the four mythological compositions at the Accademia of Venice and in the *Temptation of Saint Anthony* (at the Brera, Milan) in which, bathed in lurid stormlight, the pink, defiant effigy of Sensual Pleasure strikes so dramatic a contrast with the aged hermit crouching in anguished horror.

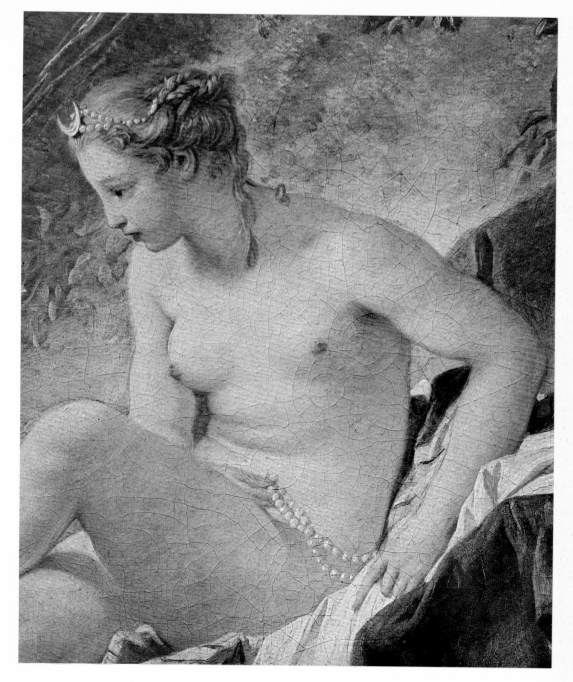

And how many more illustrations of this propensity are to be seen in the apses of Tiepolo, strewn with charming sprites and angels!

No less enamored of stage-effects than Veronese, as sensual as Titian and as versed in large-scale composition as was Tintoretto, this last great Venetian painter seems to have incorporated something of all his three 16th-century forerunners in his art. As already suggested it is his frankly 'pagan' decorations at Venice, Vicenza, Milan, Würzburg and Madrid that seem better calculated than his religious works to appeal to our modern taste.

And yet is this so certain? I cannot help suspecting that potent as are the spells woven by this magician, they may be lost on not a few of us. For Tiepolo's world is one from which all sadness, all anxieties are banished, and in which joy and beauty reign supreme; a world where life is one long carnival. Indeed, so remote is it from this harassed world we live in that many of us can but eye it enviously, mistrustfully, even resentfully. Yet might it not be wiser, instead of cavilling, to accept it as we accept the music of Mozart, and gladly visit the enchanted isle whose Prospero is Tiepolo?

We find this selfsame spirit of untrammelled, light-hearted gaiety in that charming but too little appreciated art, the rococo architecture of South Germany. The interior decoration of the churches and palaces, due to close collaboration between architects,

painters and sculptors, expresses the same outlook on life as the work of the Venetian master; which is why his frescos in the Archbishop's Palace at Würzburg fit in so well with their architectural setting. And the same spirit inspires those charming porcelain statuettes made during the same period at the Meissen and Frankenthal factories.

Had François Boucher been more gifted, and had he been less guided by the taste of his public and more by the promptings of his own creative impulse, he might have been a French Tiepolo; for both in skill and in versatility he outranged his fellow decorators of the period, Lemoyne, Natoire, the Coypels and Vanloo. And he has this further advantage over them: that he did not draw inspiration from the Carracci or Pietro da Cortona; his art is purely French. He had no use for grandiloquence and strong effects; what he liked was *le joli*, and indeed even when dealing with religious subjects he aimed above all at making the scenes and figures pleasing to the eye. His most favored field, however, was mythology, and under his brush the gods and goddesses of Greece came to look more like contemporary beaux and operatic 'stars' than like divinities. As the Goncourts remarked, his Olympus is not Virgil's or Homer's, but that of Ovid. The love-affairs of the gods particularly appealed to him; they enabled him to display his gift for painting nudes. He always painted the same young woman, winsome rather than actually beautiful, of the 'little-maid-from-school' type. The face is uninteresting, expressionless; what attracted Boucher was the grace of the young body, whose pink-and-white purity he could skillfully play off against the coarse brown torso of some god or Triton.

Mythology, pastorals, portraits, tapestry cartoons, scenes of daily life—all alike he handled with success. Today it is perhaps his small pictures of contemporary life such as *The Luncheon* (Louvre) and *The Milliner* (Stockholm Museum), that we best appreciate; and yet who can fail to be delighted by his *Birth of Venus* (also at Stockholm), with its display of young bodies softly gleaming through a filigree of love-knots formed by a broad, striped ribbon?

Though he was Madame de Pompadour's favorite artist and enjoyed her active patronage, and though regarded as a front-rank painter, Boucher had his detractors. As Marmontel caustically observed: "He did not look for the Graces in the right place. The models for his Venuses and Virgins were back-stage girls." As for Diderot, he never ceased inveighing against Boucher, accusing him of the cheapest kind of affectation, of painting "nothing but young women with rouged, simpering faces! Such art," he adds, "is the degradation of taste, color, character, composition, expression, drawing." The Goncourts, too, while recognizing his many high qualities, had a hard word for Boucher, accusing him of "elegant vulgarity." This criticism is only too well-founded; there certainly was a streak of vulgarity in Boucher and he was always far too ready to sacrifice his better instincts to facile effect. That he was an excellent draftsman is evident in the charming sketches he made on tinted paper, picked out with white; but the freedom and fluent grace of these drawings are never to be found in his paintings.

While both Tiepolo and Boucher drew freely on the contemporary theater for their subjects, they had recourse much oftener to light opera, with its showy sets and

GIAMBATTISTA TIEPOLO (1696-1770). CHRIST CALMING THE STORM, CA. 1769. (19½ × 23″)
GABRIEL FODOR COLLECTION, PARIS.

costumes, than to the tragic stage. Indeed many of their compositions give the impression
of duets or of *ensembles* with the star performers well in view, backed by the chorus.

How is it that we tolerate in Tiepolo the theatricality we find so detestable in
Boucher? The explanation is that the Venetian, even when drawing on the theater,
transfigures his impressions of it and builds them into a world of his own. Whereas

Boucher never succeeds in transforming what he borrows. We need only look at his landscapes. Really one would think that he had never set foot outside the gates of Paris, never seen a shepherdess or a country cottage save on the stage of the Opera.

Here we have another illustration of a fact already noted as regards the art of Watteau: that an artist, even when he seeks to body forth some transcendent vision, must not break contact with the real world. And, indeed, is not this one of the lessons to be learnt from the art of those noble visionaries, Michelangelo, Tintoretto, Rembrandt? The great artist transmutes reality; passing it through the crucible of genius, he uses it to integrate his secret dream. Yet always it remains the raw material of his art, lacking which his most sublime visions would be mere airy nothings.

FRAGONARD AND LANDSCAPE
HUBERT ROBERT AND VERNET

LIKE *the finishing-piece of a sumptuous firework display Fragonard brought the long fête that was the 18th century to a dazzling finale. He had certainly profited by his study of Tiepolo's work during his Venetian sojourn and he, too, became a brilliant technician. But he was more than that; indeed we readily forgive his sometimes extravagant bravura because, always and above all, he was a poet. In his art there is none of Boucher's cold and calculating sensuality; aglow with real passion, it gives a foretaste of the fervors of 19th-century Romanticism. Exponent of the voluptuous though he was, he was also an admirable painter of family groups, mothers surrounded by their children. Like Hubert Robert and Joseph Vernet, Fragonard made the traditional stay in Italy, but not with a view to imbibing the lessons of academicism. All three French artists rejoiced in the Italian sunlight that touched with gold the ruins of antiquity, and all alike found pleasure in pointing contrasts between that bygone grandeur and the daily life of the common folk of 18th-century Italy. And so accurate is their handling of light, so sensitive are their responses to nuances of color that their Italian landscapes anticipate those of Corot and the Impressionists.*

FRAGONARD

In 1752, when he was twenty, Jean-Honoré Fragonard won the Prix de Rome with a picture of *Jeroboam sacrificing to the Idols*, the set subject for the competition. In this work, as so often in 18th-century painting, the influence of the stage is manifest. The buildings in the background look like a stage set in the Bibiena manner, while the figures in the foreground, with their stilted melodramatic attitudes, might be enacting the finale of some pompous opera. Not the least curious thing about this grandiloquent composition is that the young artist, before having set foot in Italy, should have been already painting in the style of Pietro da Cortona and Solimena.

It is said that, before he left for Rome, Boucher, his teacher, took him aside and gave a last word of advice. "Now you're going to see Michelangelo and Raphael. But let me warn you, if you take those fellows too seriously, you're done for!" Fragonard is reported subsequently to have admitted that the grandeur of these two masters did in fact dismay him, and he fell to studying Baroccio, Pietro da Cortona, Solimena and Tiepolo instead, feeling that with them anyhow he might hope to compete. We may, however, wonder if modesty was his only motive for eschewing the great masters. I am more inclined to think that he turned to these second-rank artists because their temperament was more like his own; he felt much more at home with them than with the recluse of the Sistine Chapel or the majestic decorator of the Vatican.

Fragonard returned to Paris in 1761. Four years later he exhibited an enormous picture, *The High Priest Coresus sacrificing himself for Callirrhoe*, whose theme was taken from an opera. This work had immense success; all the same the artist never painted another 'historical' picture, perhaps, as some have thought, because he realized he was not cut out for this genre. That may well be so; none the less the *Coresus* exhibits all the characteristics of Fragonard's art: theatricality and that streak of suggestiveness and sensuality which runs through so much of his work. Really there is no fundamental difference between *The Sacrifice of Coresus* and, for instance, the *Sacrifice of the Rose*: both have the same tensely emotional climate, and the artist has adopted similar procedures in both pictures. It is, perhaps, an interesting point that at the time when Fragonard painted the former picture, Caylus, Cochin and many others had for nearly twenty years been preconizing a return to antique simplicity. Four years after *Coresus*, Greuze showed at the Academy his *Septimus Severus reproaching his son Caracalla for making an attempt on his life*, a remarkable early effort—anticipating David—towards austerity on would-be Roman lines. And there is a vast gulf between this picture and Fragonard's.

Fragonard was first and foremost a highly skilled and versatile technician. He felt so sure of himself with the brush, so capable of painting anything he wanted to paint and in the way he wanted, that he tried his hand at every genre and every style. He painted *fêtes galantes* like Watteau, scenes of family life like Chardin, landscapes like Hubert Robert, mythological love-scenes like Boucher and portraits like every

artist of the day. Specialist in erotic subjects though he was, he painted a *Rest on the Flight into Egypt* and an *Adoration of the Shepherds*; taken as pictures, these are such delightful works that there is no point in trying to discover what religious feeling, if any, lay behind them.

Studying his work as a whole, we are amazed no less by the great variety of his endeavors than by the curious fact that he never pressed any of them to their logical conclusion. Perseverance was not his forte. In the course of his long career, he struck out in a hundred directions; but hardly had he started out on a new path than his interest flagged, and he swerved off into another.

At the same time he had no scruples about drawing freely on other artists, past and present, but without in the least assimilating his borrowings, merely adding them

HONORÉ FRAGONARD (1732-1806). THE WASHERWOMEN, CA. 1756-1767. (18½ × 25½″) MUSEUM, AMIENS.

to his stockpile of bravura tricks. What caught his eye in Rembrandt, for example, were the deepening shadows and the shafts of light cutting across the gloom; but what had been the vehicle of Rembrandt's poetic vision became with Fragonard only a clever effect. He frankly imitated at one time or another Tiepolo and Rubens, Watteau and Rembrandt, Boucher and Van Ostade. Nothing if not capricious, he switched over from one style to another as the fancy took him. Dry, naturalistic landscapes came from his hand almost simultaneously with *The Marionettes* and the *Portrait of Adeline Colombe. The Kiss,* all in pinks and greys *à la Boucher,* belongs to the same period as the *Portrait of a Woman holding a Dog,* which is like a russet-tinted Veronese. Thus his *œuvre* is a kind of family-tree with many branches. There is the Dutch branch: finicking, elaborately worked-over pictures in which the gleaming smoothness of white flesh modulated by lush golden shadows somehow makes one think of the tiny china bedside lamps once to be seen in all French homes. Then there are boldly executed, colorful pictures such as *The Guitar-Player* (Louvre) which give the impression of having been dashed off at top speed; but clever as they are, their display of virtuosity soon grows tedious. Then we have pictures done entirely in cool colors, the pale pink flesh-tones shaded with pearl-greys and greenish blues, which bring to mind both Tiepolo and Berthe Morisot. Then, too, there are small sketches, little more than 'daubs' or confections of luscious color. Finally, and fortunately, there are some works in which Fragonard stayed his impetuous hand and gave of his best; such are the portraits of Madame Griois and Marguerite Gérard, *The Reprimand, The Marionettes* and that wonderful picture *The Washerwomen* in which the somber green of the ilex-trees contrasts so happily with the greys and whites of the terrace and the freshly laundered linen. In this work Fragonard has anticipated Corot.

One thing is clear: that if he imitated other painters this was not due to any lack of self-confidence or technical proficiency. His reason for imitating them was, rather, a wish to measure himself against them on their own ground, on their own terms; this was, in fact, a sort of sport which both amused and captivated him.

It must frankly be admitted that he was over-hasty, superficial and much too eager to parade his skill. So shallow is the pigment in some of his pictures that they lack body and the colors seem dulled as piano notes are dulled by the soft pedal. He gives the impression of having plied his brush in a state of feverish excitement; as though, feeling his inspiration was to be short-lived, he had to get it on to canvas while it lasted. What is more, he tended to infuse this feverishness, characteristic of his execution, into the scenes depicted. Thus movement plays a large part in many of his pictures, whether the subject called for it or not. Cases in point are *The Call to Love, The Bathers, The Desired Moment* and *The Fountain of Love.* In contrast with the *andante* which is Watteau's tempo, Fragonard's tempo is often an *allegro,* sometimes even an *agitato.*

Fragonard was a sensual man by nature and his art breathes sensuality, but a sensuality by no means devoid of real tenderness, genuine emotion. There is no denying that he pandered to the tastes of his age and painted works whose sole aim was to

tickle the palates of voluptuaries. But he was more than the painter of *The Swing* and *Le Feu aux poudres*. In *The Call to Love* the force impelling the lovers to Eros' altar is not merely carnal desire, there is true love as well. In fact there is a world of difference between Fragonard's ardent sensuality and the provocative displays of nudity and semi-nudity indulged in by Greuze and Boucher, each of whom deliberately set out to work on the senses of the spectator, while the artist himself stood coldly aloof, studying his effects, behind the scenes. Not so Fragonard; in pictures like *Le Verrou*

(The Bolt), *The Desired Moment* and *The Kiss* we feel that he is drawing on his own experience, with a thrill of remembered pleasure. If we cast around for literary equivalents of this curious blend of sensuality and delicate emotion, this fervent cult of "the female form divine," we find it not in *Les Liaisons dangereuses* or in *Faublas*, still less in the erotic novels of his day, but, rather, in André Chénier's *Elégies*. Actually, however (as the Goncourts aptly pointed out), there is a much closer equivalent in 18th-century literature and that is Cherubino, the young page in Beaumarchais' play who, feeling the first, delicious stirrings of desire, cannot decide whether to be a Desgrieux or a Faublas, a faithful lover or a gay Lothario.

Too often regarded as merely a confectioner of erotic pieces for the delectation of bored elderly gentlemen, Fragonard had a gift for depicting the life of country folk which was exceedingly rare in the art of the century (Greuze's would-be peasants and shepherdesses always smack of the theater). The nearest equivalent in literature is Diderot's *Jacques le Fataliste,* a novel in which we find a similar mingling of sensuality and tender sentiments, of spicy tales and tearful anecdotes. Fragonard's love for the country and the tillers of the soil was certainly sincere. He was not merely following a fashion of the day when he painted the avenues of cypresses and pines of Italy, or his groups of children playing in the mellow light of a kitchen.

Fragonard and Watteau are the only two 18th-century French painters who were truly poets, though the poetic vein in each was of a different order. On several occasions Fragonard deliberately challenged Watteau on his own ground: in his *Luncheon on the Grass* (Museum of Amiens), a shimmering, velvety, exquisitely wrought canvas, in his *Fête at Saint-Cloud* and in *The Marionettes* which is a restatement of and an improvement on the *Fête* (of which the righthand half only is retained). For *The Fête at Saint-Cloud*, charming as it is, lacks richness of texture: also the composition seems a trifle lax. In *The Marionettes* Fragonard conjures up in most delightful fashion an open-air fête at the close of a fine summer's day. This is, in fact, a work that grows on one, the more closely one examines it; the color seems to float in liquid gold and the skill with which the artist has played off the dark passages against the bright is nothing short of magical. All the same he never quite attains the ethereal heights of Watteau.

We see this again if we compare the drawings of these two fine artists—not that Fragonard's lack a distinctive charm. Sometimes, especially in his Italian landscapes, he employed a full-bodied, luscious sanguine, whereas Watteau's is usually a russet gold. Sometimes, too, he worked in sepia, laying in his outlines with a few light pencil-strokes and filling them out with wash, adding here and there a few strong accents usually in black tinged with greenish-brown, whose warm, harsh tang reminds one of notes played on the G-string of a violin. Watteau, however, is much the greater artist; he brought not merely an accurate eye but a very real passion to his observation of nature, and there is a fervor, an almost feverish intensity, in his responses to the visible world that imparts life to even his most trivial sketches. He never paraded his virtuosity; whereas Fragonard's is always very much to the fore. Not that it fails to charm—but we are always too conscious of its presence.

HONORÉ FRAGONARD (1732-1806). A BOY AS PIERROT. (23½ × 19½″)
FROM THE ORIGINAL IN THE WALLACE COLLECTION, LONDON, BY PERMISSION.

HONORÉ FRAGONARD (1732-1806). RINALDO AND ARMIDA. FRAGMENT.
A. VEIL-PICARD COLLECTION, PARIS.

Though in this canvas seething with tumultuous life are reminiscences both of Italy and of Rubens, it is charac-
teristically Fragonard's and it illustrates his fondness for composition based on a sort of gyratory movement. Obviously
he had been much impressed by Pietro da Cortona's Baroque style, which led on to his 'discovery' of Tiepolo. In *The
Marionettes* (opposite) he broaches a Watteauesque theme: a festive gathering in a picturesque open-air setting.

A curious artist who at once allures us and repels us; such is Fragonard. All too often his verve seems overdone and his showy brushwork meretricious. Yet again and again he has happy moments when he infuses an exquisite beauty into even the most voluptuous scenes and we cannot but yield to this arch-wizard's spell. His canvases breathe a sense of *joie de vivre* that at once exhilarates and charms.

Lastly, his rejection of academicism, his habit of depicting the life of his own times and his free, elliptic execution entitle him to rank as a precursor of the Impressionists. With its atmosphere of gay insouciance, its rippling light and the bluish shadows of the leafage, *The Marionettes* anticipates Renoir's *Moulin de la Galette*.

HONORÉ FRAGONARD (1732-1806). THE MARIONETTES, CA. 1770. (25 × 31 ½″)
A. VEIL-PICARD COLLECTION, PARIS.

HUBERT ROBERT (1733-1808). THE PONT DU GARD, CA. 1787. (95 × 95″)
LOUVRE, PARIS.

HUBERT ROBERT AND VERNET

In 1754, Count de Stainville, who had been appointed French Ambassador to the Holy See, brought with him to Rome his valet's son, the twenty-one-year-old Hubert Robert, who had given up an ecclesiastical career for painting. Although he had not passed the examination imposed on young men who wished to study art in Rome, Hubert Robert managed, through the Count's good offices, to secure admittance to the Palazzo Mancini, which at that time housed the *Académie de France*. Intelligent enough to realize that his early training in art had been inadequate, the young artist enrolled as a student of Pannini, the best and most eminent of those contemporary painters who, forsaking the historical landscape, had turned their attention to the ancient ruins and modern monuments of Rome.

The masters of what was known as the 'historical landscape,' Poussin, Claude Lorrain and Gaspar Dughet, had aimed at bodying forth the grandeur and harmonious beauty of the Roman scene. The ancient ruins figuring in their pictures had served a dual purpose; they not only added interest to the landscape but imparted lessons of historical or moral import to the thoughtful art-lover. For while testifying to the wonderful achievements of the Greek and Roman civilizations in the golden age of classical antiquity, those splendid ruins also served as a reminder of the transiency of all the monuments man sets up to perpetuate his fame and glorify his power. "The effect of these compositions," Diderot writes, "is to inspire in us a vague melancholy. When our gaze lingers on a triumphal arch, a portico, a pyramid, a temple or a palace, we fall to musing on the vanity of all human endeavor. All man-made things are doomed to pass away; only the solid world remains, and only time is everlasting."

However, besides these historical landscape painters (in the strict sense of the term) there were others in Rome who were more interested in the picturesqueness of ancient ruins than in the lessons to be drawn from them, and here it was Pannini who gave the lead.

Hubert Robert's coming to Rome was well timed. During the opening years of the second half of the century, the ancient world and its remains were more in vogue than during any previous period. Sightseers from every corner of Europe were visiting Rome and Naples to inspect and admire the venerable ruins of antiquity. Like all tourists they wanted souvenirs, and artists drew the ruins, made engravings of them and issued collections of prints.

Hubert Robert's arrival in Rome was followed, four years later, by that of Jean-Honoré Fragonard, winner of the Prix de Rome. A friendship sprang up between the two young artists, who made excursions together to paint the various aspects of the Eternal City and the surrounding countryside. In 1759 the Abbé de Saint-Non, a lover of the arts and of antiquities, joined forces with them, and escorted them to Naples and to Tivoli. Hubert Robert finally returned to France in 1765 and did not revisit Italy, though Fragonard returned in 1773 in the company of the financier and art-lover Bergeret de Grancourt.

The years spent in Italy had much effect on the art of Hubert Robert and Fragonard as regards their conception of the landscape; this is particularly true of the former, whose practice it became to intermingle ancient and modern: washerwomen at work amongst ruins and children playing beside fallen columns.

It was in Italy, too, that Fragonard learnt the artistic possibilities of compositions in which architectural and sculptural forms are wedded to those of vegetable life. Later on, when painting in Provence, he was fascinated by the ilex-trees with their foliage the hue of antique bronze, the plumed-helmet effects of the 'umbrella' pines, and the spearheads of tufts of corn.

Mention should also be made of the fact that he was the only painter of his century who possessed a genuine feeling for rustic life. Born in Grasse, which was more a large village than a small town, Fragonard lived the rough-and-tumble life of a country lad, working in farms and vegetable-gardens, until he was sixteen. When he married, he moved to Vaugirard, then still practically open country. Hubert Robert, though a nature-lover, regarded the people working on the land as hardly more than lay figures, useful to add a touch of color to his canvas. As for Boucher, his landscapes give us the impression that he never set foot outside Paris and that he had never seen a farm or mill save on the backdrops of the Opera. In the case of Fragonard, however, such paintings as *The Ass's Stable, Say "Please,"* or *The Storm*, such drawings as *L'Education fait tout* and *Le Four banal de Nègrepelisse* and, finally, that admirable painting *The White Bull*, testify to the artist's very real feeling for country life and his comprehension of it. True, we do not look to him for the high seriousness of a Le Nain; he sees the cheerful side of rural life, its frolics and children's laughter. Still—why not? We need not assume that this view of French peasant life in the 18th century was false.

During the remainder of his long career, Hubert Robert obstinately confined himself to painting ruins. Like his predecessor and master, Pannini, he was no stickler for accuracy and had no qualms about taking liberties with the topography of a scene. To his mind the ancient 'remains' were so many picturesque counters that he could shuffle about as the fancy took him; sometimes he went so far as to juxtapose buildings which actually were far apart. Intended primarily for the decoration of drawing-rooms, his pictures resemble nothing so much as pleasant backcloths, painted in bright, luminous colors, for some operetta by Grétry or Dalayrac.

In 1783 Hubert Robert made an expedition to the South of France with a view to painting the Roman remains in that region, such as the Arena and Temple (La Maison Carrée) at Nîmes and that famous aqueduct, Le Pont du Gard. Later on he took to depicting contemporary scenes of destruction: the burning of the Opera and that of the Hôtel-Dieu, the tearing-down of the Bastille and the Pont Notre-Dame, at Paris, and even invented imaginary ruins, as in his picture of the Grande Galerie of the Louvre as it might appear after some cataclysm.

His works can be divided into two classes. In some of his canvases, as in the work of nearly all the painters of the day, we find a taste for theatrical effect, for composition that arrests the gaze, even at the cost of over-statement. An example is

his *Dismantling of Neuilly Bridge* (Musée Carnavalet, Paris); while in other paintings, such as his *Washerwomen in a Ruined Basilica,* he gives us the impression of having studied Piranesi's engravings to good effect. There were times, however, when instead of aiming at spectacular or ornate effects, he contented himself with recording simply and sincerely what he saw. Illustrations are *The Cascades of Tivoli* and *The Spiral Staircase at the Castle of Caprarola* (both in the Louvre); also his *Italian Park* in the Gulbenkian Collection, London. In these pictures, vibrant with subtly rendered light, Robert proved himself a worthy precursor of Corot.

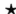

As a young man Joseph Vernet spent several years in Italy; the landscapes he painted there, though quite unpretentious, rendered the southern light with fidelity and competence. Indeed the *Ponte Rotto* in the Louvre, with its accurate and delicate handling of values and its mellow golden harmonies, qualifies to be regarded as an anticipation of the Italian Corots. And though we are bound to recognize the superiority of Corot's powers of observation, it well may be that, had Vernet persevered in this direction, he might have ripened into a truly great artist.

Perhaps because the landscapes he had painted in Italy failed to appeal to the Parisian dilettanti, Vernet changed his manner, taking to the depiction of Nature

JOSEPH VERNET (1714-1780). THE PONTE ROTTO, CA. 1745. (15 ½ × 30″) LOUVRE, PARIS.

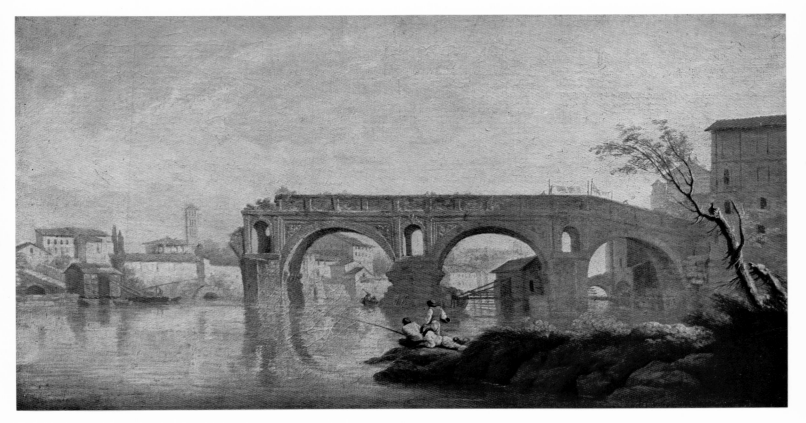

under her more emotive aspects. The 'man of feeling' was coming into his own during the last half of the 18th century and he expected the painted landscape to be something more than a scene agreeable to the eye. Hence the fashion for what the aestheticians of the day called the "heroic landscape": that is to say, gigantic, snow-clad mountains, crags and foaming torrents. Vernet went so far as to jot down in his notebooks a list of the accessories he would do well to include in his landscapes, if he wished to please his public: "waterfalls, big rocks, fallen tree-trunks, ruins, wild and desolate scenery."

The "vistas of haunted gloom" that Vernet painted so as to provide the addicts of this early terror-romanticism with the thrills they craved for strike us today as being quite as artificial, made-to-order, as Boucher's prettified landscapes. Still his gales and thunder-storms were thoroughly to the liking of a public who expected a picture to tell a story, preferably an exciting one. The emotions they derived from Vernet's paintings were much the same as those evoked by Greuze's *Paralytic* and *A Father's Curse*. Indeed Vernet actually took the subject of one of his pictures, *The Alpine Shepherdess* (Musée Calvet, Avignon), from an incident in one of Marmontel's *Moral Tales*. (If the spectators whom this highly sentimental idyll moved to tears had known the Alps otherwise than through travelers' tales, Vernet's quaint conception of the Alpine scene would more likely have moved them to laughter.)

In 1758 Madame de Pompadour's brother, the Marquis de Marigny, then Director of Public Buildings, gave Vernet an order for a series of large pictures of the chief French seaports. It was intended to reproduce these pictures in engravings which would bring to the public eye the prosperity of French overseas trade and the magnificence of the French fleet. Marigny gave the artist very detailed instructions, specifying not only the ports he had to visit, but also the viewpoint from which each picture was to be painted. For about ten years Vernet roved the coasts of France, making wash-drawings accompanied by written notes recording the various colors of the sky, the salient features of each landscape and so forth. Once he was back in his studio, he fell to painting from the *data* supplied by his notes and drawings.

These views of the French ports were highly thought of at the time. Today, however, we have a feeling that the artist, probably because he found himself handicapped by de Marigny's meticulous instructions, tended to fritter away his creative energy on details, and that this extreme attention to minute particulars has led to a certain aridity, not to say tediousness. Thus while there is no denying the documentary interest of these canvases, they rank less high as works of art.

THE COLOR OF VENICE

CANALETTO · GUARDI

Dᴜʀɪɴɢ *the 17th century, in Italy, in France and in Holland, landscape-painting had developed into a recognized genre, in which nature reigned supreme and the human element was merely an accessory. French and Italian artists sponsored what was called the "historical landscape," that is to say a natural scene to which ancient ruins added a note of majesty; Dutch artists, on the other hand, aimed at faithfully rendering the various aspects of their country, with a special emphasis on its vast horizons and ever-changing skies dappled with wind-borne clouds. But with the coming of the 18th century new tendencies arose; thus artists began to study more closely the play of light and to render light effects more accurately. Though at Rome such artists as Pannini painted 'views' of the Eternal City, it was the Venetians Canaletto and Guardi who were the true creators of the urban landscape. Even when their theme was the countryside they never failed to embellish it with buildings: ruins, farmhouses, or villas. But it was above all their incomparable mother-city, Queen of the Adriatic, that they never wearied of painting under her many aspects: not only the canals thronged with gaily decorated barges and gondolas on feast-days, but also the poorer districts and the ancient houses with their crumbling façades scarred by the sea-winds.*

THE COLOR OF VENICE

As early as the 17th century Venice could boast of an artist of some talent who specialized in painting views of the city; this was Luca Carlevaris. But it was not until the 18th century that two really outstanding painters, Antonio Canal (known as Canaletto) and Francesco Guardi, applied themselves to depicting the brilliant life of their city under its many aspects.

Their art is a series of variations on a single theme, that of the colorful, ever-changing life of Venice, with her maze of canals thronged with gondolas and *peote*, her broad piazzas teeming with motley crowds. Canaletto specialized in far-flung vistas such as the long recession of the Grand Canal flanked by the huge dome of S. Maria della Salute, or the coronation of the Doge on the majestic Giants' Staircase. Guardi, on the other hand, showed a preference for small canvases giving glimpses of the city's intimate life: for example, a tranquil square in which one or two people are loitering, or an arcade under which a pedlar is crying his wares.

In the 18th century Venice was no longer the metropolis of the race of merchant-adventurers and hardy warriors who had waged war against the Turks and the rival republic of Genoa, had hoisted the flag of St Mark in many of the cities of the Levant, maintained a flourishing commerce with the East and amassed huge stores of treasure in her island palaces and churches. Yet, though politically she had fallen on evil days, Venice had kept her old prestige and luxurious way of living. And, above all, she was unique among the cities of the world. The Doge's marriage with the sea was not mere idle pageantry, but an effective symbol of the life of this strange amphibious city whose very life-blood pulsed in her canals.

The Venetian year was one long round of festivals, greatest of which was the Carnival. Considering the kaleidoscopic brilliance of Venetian life, with men and women of twenty or thirty nationalities rubbing shoulders in the loveliest, most picturesque surroundings, how could visitors have failed to want to bring back pictures of what they saw, and how could the artists who supplied these have failed to take a very real pleasure in their *métier*?

Thus it was with Canaletto and Guardi. Canaletto's special gift was his ability to represent public and private edifices with absolute exactitude and in flawless perspective. Indeed, he was nothing if not meticulous; no architectural detail escaped his vigilant eye. Even in the remotest corners of his pictures, the sculpture on a cornice, the individual tiles of a roof are clearly indicated. Sometimes, indeed, we could wish him less painstakingly precise, and if he just escapes dullness on these occasions, it is thanks to the wonderful purity of his light, the crystalline sheen that envelops the buildings in his pictures, giving them the sparkling clarity of Montesquieu's prose.

Given these qualities, it is easy to understand why Canaletto's paintings were so much sought after by foreign visitors, especially wealthy English travelers. Canaletto was, in fact, invited to London, where he stayed nearly ten years and painted a great

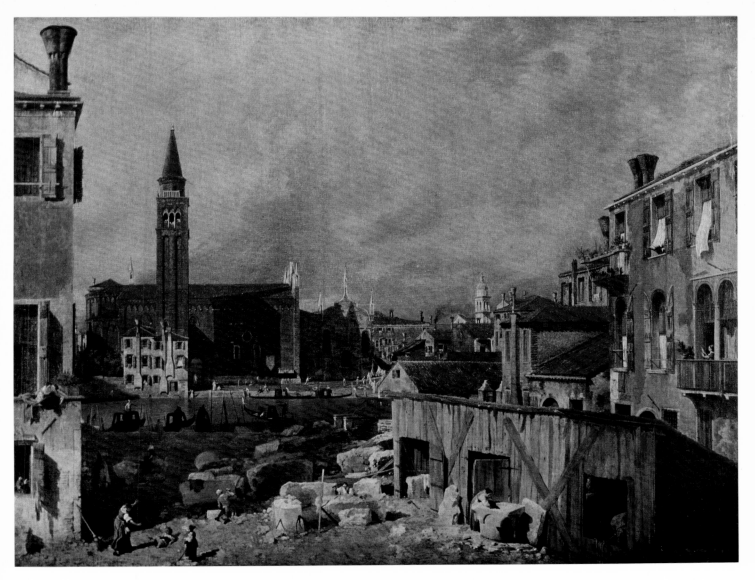

ANTONIO CANALETTO (1697-1768). VIEW OF VENICE: THE STONE-MASON'S YARD. (47½ × 63½")
NATIONAL GALLERY, LONDON.
REPRODUCED BY COURTESY OF THE TRUSTEES

many landscapes. Amongst his Venetian paintings, such works as the *Riva dei Schiavoni* (Pinacoteca, Turin) and *View of the Grand Canal* (Accademia Carrara, Bergamo) rank him among the great masters of architectural landscape.

Francesco Guardi was less architecturally minded and more painterly than Canaletto. If the latter's work may be said to give us perfect prose, Guardi's is all delicious poetry. True, the perspective of his landscapes may sometimes be faulty—but what matter? Such minor defects are redeemed by the charm and delicacy of his color. With a subtly composed palette of dove-greys, faint pinks and misty blues shading off into lilac, he gives the picture surface an iridescent sheen like that of pearls or opals, and he has a way of peopling his canvases with tiny figures each strongly individualized and lifelike, though rendered with just a few brief, seeming-casual touches. We must not look to

Guardi for the precise, well-defined linework of Canaletto, who indeed seems to employ the ruler and set-square quite as much as his brush. Guardi's calligraphy is free and fluent and he delights in spangling his canvas with tiny specks of light glittering on wave crests or the iron beak of a gondola. He did not confine himself to depicting the famous sights of Venice, St Mark's and the Piazza, the lagoon with San Giorgio Maggiore looming up on the horizon. Again and again he painted scenes in the less fashionable districts, some small deserted courtyard in the shadow of a pink campanile, with, perhaps, a lone horseman, wrapped in his cloak, hurrying to a tryst.

This fondness for illustrating the everyday life of Venice which we find in Guardi's landscapes is evident also in two pictures now in the Museo Correr, one of them depicting a marionette-show in the parlor of a convent, the other of the Ridotto with a milling throng of masqueraders. The poetic side of his temperament comes to the fore in those five pictures at the Church of the Archangel Raphael at Venice in which he gave, for

FRANCESCO GUARDI (1712-1793). GONDOLA ON THE LAGOON, 1750-1760. (10 × 15″)
POLDI-PEZZOLI MUSEUM, MILAN.

FRANCESCO GUARDI (1712-1793). VENETIAN COURTYARD. (8½×6″) NATIONAL GALLERY, LONDON.
REPRODUCED BY COURTESY OF THE TRUSTEES

FRANCESCO GUARDI (1712-1793). THE DOGE IN THE BUCENTAUR, ASCENSION DAY. (26½×39½")
LOUVRE, PARIS.

once, free rein to his imagination; here he has transformed the story of Tobias into a delightful fairy-tale, lavishing on each canvas the most exquisite color harmonies.

There can, however, be little doubt that Guardi's masterpiece is his *Gondola on the Lagoon*, one of the most treasured possessions of the Poldi-Pezzoli Museum at Milan. The soft blue of the water, the palely glimmering architecture and the black shape of the gondola somehow convey the effect of music as much as that of painting— the effect that Whistler was aiming at when he applied himself to studying Japanese art.

Guardi has often been described as a forerunner of the Impressionists and this is true so far as his method of dappling the canvas with small, excited touches and the loving care with which he renders the light enveloping objects are concerned. But, unlike Monet and Pissarro, he never employs high-pitched color. His palette consists almost entirely of whites, greys, ochres, muted blues; moreover, he makes a highly skillful use of black. In fact his discreetly subdued color harmonies assimilate him more to Corot, and particularly to Boudin, than to the Impressionists.

TOWARDS IMPRESSIONISM

THE LIGHT OF FRANCE
AND THE LIGHT OF ENGLAND

DESPORTES · MOREAU THE ELDER

GAINSBOROUGH · WILSON · CROME

WHILE Joseph Vernet, Hubert Robert and Fragonard were feasting their eyes on the light of Italy, which saturates their canvases, Desportes was setting to paint from nature scenes of the Ile-de-France, that province of ancient France centered on Paris, whose light has always been the painter's joy. His sketches are remarkable for their disregard of all convention, the accuracy of their color, and their bold execution; indeed a hundred years had to elapse before once again landscape was treated in this manner. Like Desportes, Moreau the Elder painted the environs of Paris; his execution is less robust and he has not the same breadth of vision, nevertheless his sense of light is wonderfully accurate. Following the custom of his time, Richard Wilson, "the Father of British Landscape," worked much in Italy, but we are inclined to think he made best use of his talent when painting English scenes. However, he could never quite rid himself of the conception of the "historical landscape" associated with Claude Lorrain. Crome, however, following the lead given by the Dutch, depicted with fine sincerity the scenery of Norfolk, and indeed revealed to his compatriots the beauties of their native land.

THE LIGHT OF FRANCE

Of all the exponents of landscape-painting in 18th-century France, it was François Desportes and Jean-Baptiste Oudry, the animal painters, who interpreted nature with the greatest veracity and sensitivity. At first sight, this might seem paradoxical; nevertheless, there were good reasons.

Desportes specialized in painting, with a scrupulous concern for lifelike accuracy, forthright and vigorous hunting-scenes, pictures of the royal packs of hounds and also of menagerie animals. Oudry followed in his footsteps and, besides his depictions of unusual kinds of animals, we have some still lifes by him, which, with their breadth of vision and structural solidity, often recall those by Courbet.

In painting the landscapes which form the backgrounds of their paintings, Desportes and Oudry were not content, as Poussin and Claude had been, with making sketches done on the spot in pen and ink or sepia and bistre washes. They took their painting outfit with them into the countryside and painted directly from nature, thus practicing open-air painting a hundred years before Courbet and the Impressionists. In his biography of his father, Claude-François Desportes writes as follows:

ALEXANDRE-FRANÇOIS DESPORTES (1661-1743). LANDSCAPE, ENVIRONS OF PARIS. (11 × 20½″)
MUSEUM, COMPIÈGNE.

"When he went to the country he always took with him tin boxes containing his paint-brushes and a fully garnished palette. Also he always carried a specially made walking-stick with a steel point enabling him to plant it in the ground. It had a steel knob that screwed on and off, and in this was a small rack to hold his portfolio and paper. He always had this outfit with him when he visited friends in the country; it was a constant source of enjoyment to him and he never failed to make good use of it."

About twenty years ago, some landscape studies after nature, painted by this artist in the Oise valley, were discovered. Aerial perspective, the recession of planes in light, is rendered in these paintings with such ease and accuracy that, at first sight, we might be tempted to attribute them to a mid-19th century artist.

Similar accounts of Oudry's practice have come down to us. Thus one of his contemporaries, Abbé Gougenot, reports that "he never went to the country without bringing along a little tent, sitting in which he drew and even painted landscapes." These landscapes, made by Oudry in the Bois de Boulogne and the Forests of Saint-Germain and Chantilly, figure in the backgrounds of his hunting-scenes, such as the one in the Toulouse Museum showing Louis XV at the kill beside the lake of Saint-Jean-aux-Bois. The *Death of the Wolf* (Nantes Museum), in which the background plays a large part in the composition, can hold its own beside Courbet's hunting-scenes.

LOUIS-GABRIEL MOREAU, THE ELDER (1739-1805). VIEW OF THE CHATEAU DE VINCENNES FROM MONTREUIL. (18 × 34″) LOUVRE, PARIS.

LOUIS-GABRIEL MOREAU, THE ELDER (1739-1805). VIEW OF THE SLOPES OF BELLEVUE FROM SAINT-CLOUD.
CA. 1780-1785. (22 × 31 ½″) LOUVRE, PARIS.

The two influences predominant in 18th-century French art—that of the Roman and Venetian Schools and that of the Dutch and Flemish painters—took no effect whatever on one highly interesting French artist of the period. Louis-Gabriel Moreau (called Moreau the Elder to distinguish him from his brother, Jean-Michel the draftsman) did not make the traditional journey to Italy or go through the academic mill. His *œuvre* consists of small oil-paintings and gouaches done in tiny brushstrokes, his favorite subjects being views of Paris and the suburbs, of large parks such as Bagatelle and Marly, and of the near-by country villages. Moreau showed wonderful skill in rendering the limpid light of the region of the Ile-de-France, and in his *View of the Slopes of Bellevue from Saint-Cloud* (Louvre) and *Environs of Paris, Montreuil* (Museum of Compiègne), he depicts the gently undulating hills bathed in the soft, translucent atmosphere characteristic of this part of France to the happiest effect.

THE LIGHT OF ENGLAND

Although the English are renowned for their love of nature and country life —evidence of which can be found in the work of many 18th-century English writers— the landscape made a relatively late appearance in English painting and some time was to elapse before it attracted the attention of connoisseurs. At this time Poussin and Claude Lorrain were the most popular painters and there was eager competition for their canvases. In fact the only landscape that then found favor with the English dilettanti was the 'historical landscape' portraying the Italian countryside in all its nobility and harmony, with the addition, needless to say, of some picturesque ruins. The first English artists who ventured to depict their own countryside were treated with indifference or even contempt. Wilson spent most of his life in abject poverty, while Gainsborough, who liked nothing better than painting landscapes, had to abandon them and turn portraitist to earn a living.

Richard Wilson started off by painting portraits and, rather late in his career, went to Italy, where he lived for several years. During this period he painted views of the Roman Campagna and the outskirts of Naples; these were much admired by Joseph Vernet when he saw them in Rome. On his return to London Wilson had a cold reception from public and critics, and his landscapes went begging; to make things worse, he fell foul of Reynolds. His lack of success and the hardships it entailed embittered him, and he finally retired from London to the home of some relatives at Llanberis in Wales, where he died.

In Wilson's work we find a struggle between two tendencies. On the one hand, he wished to paint nature exactly as he saw her and, on the other, he could never shake off his respect for the tradition of the historical landscape, as exemplified in the paintings of Poussin and Claude. This accounts for the unevenness of his work; when, however, discarding rules and conventions, he gave free play to the emotions kindled in him by the sight of nature and to his instinctive lyrical reponse, he proved himself a marvellously sensitive colorist. In some of his Neapolitan landscapes there is a fine atmospheric truth, while in his Welsh landscapes he displays a happy gift for rendering the huge masses of sunlit mountains, and bringing home to us their majestic solitude. In the annals of landscape art, Wilson is the link between Claude Lorrain and Corot, and Turner, even more than Constable, was to profit by his example.

The first English landscape-painter who broke with the conventions of the historical landscape and, following the example of the Dutch, sought to depict nature as he saw it, was John Crome, known as "Old Crome" to distinguish him from his son who also was a painter. Although he was born in 1768, he belongs as much to the 19th as to the 18th century; for he did not make his mark until he was nearing his forties. The son of a poor weaver in Norwich, Norfolk, he started his career as an apprentice to a coachwork and sign painter. It was his heart's desire to be an artist and he took every opportunity of studying pictures of the Dutch school in private collections, while

THOMAS GAINSBOROUGH (1727-1788). ROBERT ANDREWS AND HIS WIFE, CA. 1748-1750. DETAIL.
ANDREWS COLLECTION, REDHILL, ENGLAND.

trying his hand at sketching the charming scenery surrounding his native city. A man of little education, Crome painted without troubling overmuch about the rules of art or abiding by convention. His boldness of vision and unsophisticated feeling for nature entitle him to be regarded as the pioneer of the 19th-century landscape, a precursor of Constable and also Théodore Rousseau, and there is no doubt he would have heartily applauded Constable's famous declaration: "When I sit down to make a sketch from nature, the first thing I try to do is to forget that I have ever seen a picture."

This brief survey of 18-century English landscape-painting would be incomplete if mention were not made of a new genre which made its appearance about this time and was destined for great popularity; I am referring to the watercolor.

We must not forget, however, that, to start with, the watercolor was no more than a pen-drawing reinforced with a light wash of ink or sepia, over which was floated a coat of thin, transparent color. Thus there were two distinct stages in its making. The pure watercolor, in which the color is applied directly without a preliminary monochrome ground, as has been the general practice during the past hundred and fifty years, came into vogue only at the beginning of the 19th century. Thomas Girtin (1775-1802) was the first to break with the earlier technique.

JOHN CROME (1768-1821). THE PORINGLAND OAK, 1818?
(49 × 39½″) NATIONAL GALLERY, LONDON.
REPRODUCED BY COURTESY OF THE TRUSTEES

The 18th-century watercolorists painted country landscapes and views of towns with equal assiduity. The most noteworthy exponents of the genre during this period were Paul Sandby, who is regarded as the father of the English watercolor, and John Robert Cozens. Paul Sandby painted landscapes which were popular with the public. Cozens, son of the painter Alexander Cozens, made several journeys to the Continent, including one in the company of that noted eccentric William Beckford, author of *Vathek*. Constable went so far as to say that Cozens was one of the greatest geniuses in the art of the landscape. This eulogy is certainly excessive, but the fact remains that Cozens showed more originality than his contemporaries and that, in his very individual handling of color, he anticipated Turner. Outdoing Wilson, he painted watercolors in Italy and Switzerland in which he applied himself to depicting the mountains in all their elemental grandeur, to the exclusion of trivial details and anything that might recall man's presence.

It may seem strange to associate the name of Thomas Rowlandson, who is chiefly known as a caricaturist, with those of the landscape-painters Sandby and Cozens. But Rowlandson was something more than a painter of comical old men and of pretty girls displaying their ample charms. He had a very delicate sense of color and his work includes charming views of the countryside, small seaports, towns and parks sprinkled with tiny figures rendered with much accuracy and humor.

Wilson, Gainsborough, Old Crome and the watercolorists were the forerunners of the great 19th-century English school of landscape-painters, which includes such illustrious names as Constable, Cotman and Turner. It is noteworthy that these 18th-century painters already displayed those tendencies which were to characterize English landscape-painting in the years to come: fidelity to natural appearance combined with a poetic feeling for the English countryside, finding expression through the medium of color.

THIRD PART

THE AFTERMATH
FROM THE FRENCH REVOLUTION
TO THE DAWN OF THE XIXth CENTURY

MORALS AND CIVIC DUTY

TOWARDS ROMANTICISM

MORALS AND CIVIC DUTY

GREUZE · DAVID

WITH his moralistic pictures Greuze claimed to be preaching virtue to his compatriots, much as thirty years later David, when pictorializing momentous incidents of Roman history, sought to give them lessons in civic duty. The rhetorical and theatrical element in the work of both these painters is all too evident. Greuze's picture-sermons, which Diderot so much approved of, originated in the mind of an artist consumed by ambition; as for the return to antiquity sponsored by David's art, this was due to several factors: the research-work of contemporary scholars and artists, the interest aroused by the excavations at Herculaneum and Pompeii, and a healthy desire to reinvigorate an art emasculated by convention and over-deferent to patrons' tastes. At one time it seemed possible that the German painter Mengs, seconded by his compatriot Winckelmann, would be the pioneer and figurehead of the new movement. Mengs, however, was but an indifferent painter, whereas David was beyond all question a born artist. Thus David took the lead of the movement and his position as leader was consolidated by the Revolution.

MORALS AND CIVIC DUTY

Of all 18th-century painters it was perhaps Greuze who had the greatest and most lasting success. His moralistic pictures, *The Village Betrothal*, *The Punished Son* and *A Father's Curse*, moved tender souls to tears and elicited page after page of ecstatic eulogy from Diderot, whose cult of the painter had begun in 1761 on seeing the first of the three pictures named above. Two years later, in his description of the Salon at which Greuze exhibited *The Paralytic tended by his Children*, he wrote: "This kind of painting appeals to me; it breathes morality. It is high time our artists ceased pandering to vice and profligacy, and we should all be glad to see that at long last painting is joining with the poetic drama in improving us, instructing us and pointing the way to virtue. Do not lose heart, friend Greuze! Preach morality in your art, and keep to your present path." And, in reply to certain criticisms of the artist, he concluded: "Anyhow, whatever others may think of him, Greuze is a painter after my own heart." These sentiments, coming as they did from the author of *Les Bijoux indiscrets*, must have struck Diderot's readers as odd, to say the least of it. In 1765 we still find Diderot talking in the same vein. "Greuze is the painter we have all been waiting for, the first to deal with contemporary mores in his art and to present sequences of incidents which could quite well be turned into a novel." However, in 1769, after Greuze's ill success at the Academy, Diderot completely changed his tone and curtly declared: "I no longer like Greuze."

But the public continued to like him; his 'improving' pictures were perfectly suited to the new cult of sensibility and all the virtues which was to be officially endorsed after 1789, in the guise of republican puritanism. It is odd to see how, in using art to preach morality, Diderot, a professed atheist, was reverting to the tradition of the Church, which for many centuries had seen in art a means of bringing home to men the truths of revealed religion.

No less successful than Greuze's edifying paintings were those he made of attractive young girls. Simple souls were charmed by these visions of fresh, untainted girlhood. To the more sophisticated, however, those budding, half-naked breasts, yearning eyes, languorous attitudes and parted lips suggested ideas which were the very opposite of innocent; not that this detracted in any way from the success of these paintings— quite the contrary!

Greuze's art is distasteful to us today for several reasons. For one thing, his execution is flabby and conventional and his color lacks warmth. All seems faked, the feeling as well as the technique. Indeed sincerity and truth are conspicuously absent in his moralizing canvases; the persons he depicts are merely acting a part, and acting it badly at that. As for such pictures as the too famous *Broken Pitcher*, *The Two Friends* and *The Morning Prayer*, their dubious air of innocence and simpering indelicacy is nothing short of nauseating. The frank sensuality of Boucher or Fragonard is infinitely preferable. All the same, some of Greuze's work is not without merit. A few of his

portraits, painted with a thick impasto and in strong, resonant color, show that he had learnt something from Rubens; examples are *Wille the Engraver, Madame de Porcin* and the small portrait of young Bertin at the Louvre, where the fluent execution and the freshness and vigor of the colors remind us of Renoir.

The idea of a 'return to antiquity,' which played so large a part in shaping the mentality of the latter half of the 18th century, was first mooted round about 1750 and gradually gathered strength.

After serving in the army, the Comte de Caylus (born in 1692) traveled in Italy and Asia Minor. On his return to Paris, he gave himself up completely to his passion for archaeology and the arts. Not content with being the man of learning whose knowledge stems from books alone, he frequented artistic circles, studied methods of technique and even experimented with them himself. While publishing a number of books dealing with classical antiquity, he also sought to reform the art of his period. An avowed enemy of mannerism, he aimed at reinstating the academic doctrines of the 17th century and bade artists go to school with the great masters of antiquity. His influence on the artists and connoisseurs of his time would have been more effective, had it not been somewhat premature.

In 1749 Madame de Pompadour's brother, then the Marquis de Vandières, was appointed Supervisor of Public Buildings. With a view to improving his taste, he went to Italy, accompanied by the architect Soufflot, an art critic, the Abbé Le Blanc, and a designer and engraver, Charles Nicolas Cochin the Younger. Cochin subsequently published a number of books and pamphlets expounding the ideas he had gleaned from the works of art he saw in Italy. Accusing contemporary French painting of a lack of naturalness and truth, he suggested that it should seek inspiration from classical art, but also from nature, and would do well to follow the example of the Venetians. Nevertheless, he warned artists against the slavish imitation of antiquity; thus, when he saw David's works, he must have realized that the artist's excessive interest in archaeology had drained them of all vitality.

The excavations at Herculaneum, begun in 1738, were followed in 1755 by those at Pompeii. Although the King of Naples made difficulties about letting the results be seen, they had considerable influence, especially owing to their revelation of what had hitherto been an uncharted domain of art, Graeco-Roman painting.

Towards the middle of the century, a Venetian engraver, Giambattista Piranesi, was profoundly impressed by the remains of ancient architecture to be seen in Rome, and his large engravings of these buildings admirably express their massive, time-scarred, awe-inspiring grandeur. At about the same time, Vien, a protégé of Caylus, returned from Rome and exhibited pictures inspired by the painting at Pompeii; these works show at once the influence of antiquity and a striving for simplicity. Unfortunately, Vien had very little individuality and his would-be Pompeian style was as artificial as the would-be Turkish and Chinese styles which had been in vogue thirty years earlier. However, several painters who were to outstrip their master studied in Vien's studio: Regnault, Suvée, Peyron and, greatest of all, David.

Also towards the middle of the century, a German artist, Anton Raphael Mengs, whose father had encouraged him to make painting his career, settled in Rome. He soon had a following among the Roman art-lovers and was acclaimed another Raphael. His huge fresco, *Parnassus*, at the Villa Albani is probably one of the most unsatisfying works of art the world has seen—a *locus classicus* of tedium. In it Mengs succeeded in embodying every blemish the artist should avoid: pretentiousness, insipidity, weakness of form, inaccuracy and crudity of color.

Ancient art was the ruling passion of another German, Johann Winckelmann, who arrived in Rome about the same time as Mengs and soon gained the reputation of being the most notable scholar of the period. In his writings he did not confine himself to the study of antiquity, but also expounded an artistic ideology. His view was that ideal beauty could be achieved only by the close study of Graeco-Roman art and the work of the master whom he styled "the divine Raphael."

These theories met with much success in Rome and gave rise to endless discussions in artists' studios and the salons of the dilettanti, where there were as many foreigners as Italians. Indeed at this time Rome bade fair to usurp the place of Paris and become the international headquarters of the new form of art, as defined in an Italian publication of 1785: "Paintings and statues are no longer to be treated merely as sources of momentary pleasure to the eye. The philosopher looks to them for truth and high emotion and would have them speak both to the intellect and to the heart."

What worlds away are these philosophical elucubrations from the conceptions of painting sponsored by Watteau, Chardin, Tiepolo, Longhi and Fragonard!

At last a painter whose forceful personality was capable of implementing these doctrines and embodying them in his art appeared on the scene. After studying under Vien, Jacques Louis David obtained the Prix de Rome in 1774 and he left

JEAN-BAPTISTE GREUZE (1725-1805). A FATHER'S CURSE: THE UNGRATEFUL SON, CA. 1765. LOUVRE, PARIS.

JACQUES-LOUIS DAVID (1748-1825)
THE OATH OF THE HORATII
BEFORE THEIR FATHER, 1785.
DETAIL. LOUVRE, PARIS.

for Italy in the following year. So far he had been no more than a docile, industrious pupil whose sole ambition was worthily to follow in the footsteps of his illustrious predecessors. Thus his *Combat between Minerva and Mars* (in the Louvre) has an air of having been inspired by a scene in some opera and its delicate, subdued color strikes us as being far more in the tradition of Boucher and Lemoyne than in that of his teacher Vien.

On his arrival in Rome David found the classical reaction in full swing. However what impressed him most was the work of Caravaggio and his disciples. But he also came under the influence of his friend Quatremère de Quincy, who had begun by being a sculptor and had a cultured, orderly turn of mind. Quatremère and Giraud (also a sculptor) were responsible for arousing David's interest in ancient art. It was not, however, until he painted his *Date obolum Belisario*, exhibited in the 1781 Salon, that David's work began to indicate the change that was coming over his artistic outlook. This sedate, severely classical painting revealed the influence of Poussin and, despite its rather drab color, met with immediate success. For this picture was exactly in keeping with the spirit of the time; breaking with the art of voluptuous grace, it embodied so well the new aspirations towards simplicity, grandeur, the dignified aloofness of ancient sculpture, that the public was indulgent to its all-too-evident shortcomings.

All the same, for several years yet, David seemed undecided what path to follow. Then, at a performance of Corneille's *Horace*, an idea came to him for a picture, which he brought to completion in Rome. All Rome flocked to his studio to see *The Oath of the Horatii* and it was equally successful in Paris, when exhibited at the 1785 Salon. Two years later he scored another success at the Salon of 1787 with *The Death of Socrates*, and again, in 1789, with his *Lictors bringing to Brutus the bodies of his Sons*. By now David was more than a talented painter, he was coming to be hailed as the spokesman of the new ideas. Though the awkwardly composed *Brutus* was far from being one of his best works, this did not tell against the artist's popularity; he had made proof of his ardent political faith and that was all that mattered. The new social order now taking form was coming to regard David as its representative in art. He was to be the painter of the Revolution, pending the day when he became the painter of the Empire. Within a very few years a drastic change had come over public taste and artists who persisted in painting in the old manner now seemed hopelessly out of date.

What was the aftermath of this artistic revolution known as the Return to Antiquity?

Pseudo-classicism—to give it its proper name—spread throughout Europe and became an international art. Its manifestations in architecture were many and diverse, whilst its representatives in the field of sculpture were Canova in Italy and Thorwaldsen in Denmark. In France, thanks to David's prestige, pseudo-classicism became the official art, sponsored by each successive Government. As soon as 1815, however, the younger generation was beginning to find it outmoded.

After being responsible for the abolition (in 1792) of the Royal Academy of Painting and Sculpture (which he held responsible for the setbacks of his early days) David agreed to its restoration by Bonaparte, who made him a member of it and, in 1804, appointed him Painter in Chief to the Emperor. His official position enabled him to lay down the law to other artists and impose his views on the younger generation.

But pseudo-classicism was doomed to sterility, since it was based on the philosophical speculations of intellectuals such as Winckelmann and Quatremère de Quincy, and not on the practical experience and discoveries of the artists themselves (as was Impressionism in later days). Revolutions in art are made by great artists and not by theorists. David is at his best in his portraits and in the paintings stemming from contemporary history and not from the quest of some pedantic *beau idéal*; such are his *Marat Assassinated*, *The Coronation of Napoleon I* and *The Distribution of the Eagles*.

The vogue of pseudo-classicism may also be explained by the fact that some of its principles—the cult of ancient art, austerity, simplicity, the inculcation of private and civic morality—fell in line with the political and social ideas current between 1789 and 1815. David's art could hardly have failed to make good with a generation that was brought up on Plutarch and the *Conciones* and was responsible for the Revolution. It was no less warmly approved of by Napoleon who likewise was a great admirer of classical antiquity, though it was the Rome of Caesar and Augustus he admired rather than that of Brutus.

TOWARDS ROMANTICISM

BLAKE · FUSELI · GOYA

SIMULTANEOUSLY *with the return to antiquity there set in another reaction against the tendencies of that elegant French art which had held all Europe in its spell; this was the Romantic movement. Its first manifestations were sporadic and it was only later that the movement coalesced and gathered strength. People were growing somewhat weary of the studied refinement and glittering sophistications of that charming but exacting life whose tone was set by the Parisian élite, and there was now much talk of a return to simplicity, to a naïver, more primitive way of living. Religious faith has weakened and the much-vaunted pleasures of the intellect were beginning to pall; thus many sought to find a compensation in the thrills of the mysterious and terrifying, the night-side of man and nature. Though some symptoms of this appeared in French literature, French painting, right up to the end of the century, remained firmly rooted in reality. It was in England that two highly original artists, Blake and Fuseli, applied themselves to bodying forth their eerie visions and, drawing as they did on the unconscious, they pointed the way to Surrealism. In Spain, too, at the same time in his paintings and engravings Goya was depicting the monsters and phantasmagoria that obsessed his waking dreams.*

TOWARDS ROMANTICISM

The harbingers, as far as painting is concerned, of the great movement that was to go by the name of Romanticism were two artists working in England: William Blake and Johann Heinrich Füssli, better known in England and America as Henry Fuseli. Up to the present time the latter, a Swiss, has not been given due recognition outside his native country. Nevertheless, this artist is important for the vital part he played in the great changes that came over the whole conception of art and literature at the close of the 18th century.

During his lifetime, though his poems and pictures were eagerly sought after by a small band of friends and initiates, William Blake was looked upon by most of his contemporaries as a crank or even mentally deranged. Today, however, his genius as a poet is universally recognized; on the other hand, outside of England and America, there are few prepared to regard him as a truly great painter.

Personally I must confess that I, too, fail to discern in Blake those distinctive gifts that go to make an artist. Not that I take exception to the 'literary' turn of so much of his painting; an artist is within his rights in choosing subjects of this order if they interest him. What matters is his way of expressing them, and the trouble with Blake was that he had no truly painterly and personal vocabulary at his command in which to body forth his visions. Hieronymus Bosch delighted in transposing into painting themes whose complicated symbolism remained obscure over a long period. Generations of art historians tried to puzzle them out and some have thought to find the key to the mystery by way of psychoanalysis. Recently a German historian, Wilhelm Fränger, has proved that the central panel of Bosch's triptych at the Escorial, *The Garden of Earthly Pleasures*, was almost certainly intended to figure in the secret rites of a 15th-century heretical sect, whose dogmas the panel illustrates, and that Bosch himself probably belonged to this clandestine group. However this may be, Bosch is unquestionably a painter born and expresses himself in a graphic vocabulary as original as it is remarkable.

Or, to take another example, in his woodcuts on the theme of the Apocalypse, Albrecht Dürer succeeded in giving a plastic interpretation of symbols that hardly seemed to lend themselves to this; he thus brought off a feat in attempting which many another artist has failed. We need only compare the Dürer woodcuts with Blake's work to see the gulf between a great visionary who was also a great artist and another who was never able to translate his visions into the language of forms.

To make matters worse, Blake fell into the same error as Fuseli. His plastic vocabulary consists of borrowings and is full of echoes of Michelangelo and Hellenistic sculpture at its most academic. The strongly marked muscular structure of his figures is a congeries of what might be termed "anatomical clichés"; many a third-rank illustrator of the day, after a close study of antique statuary of the decadent period, turned out exactly similar figures. Thus we soon weary of Blake's stereotyped patriarchs with their long,

billowing beards, and his monotonously stylized drapery. Like a pupil of David, now forgotten, Blake might have been nicknamed *Le Père la Rotule* ("Daddy Kneecap"), so insistently does he apply the same banal formula to depicting different parts of the body. One is led to wonder whether Blake—who had a habit of walking naked in his garden with his wife, likewise in the nude—ever really looked at an unclothed human body outside the anatomy books provided for the use of budding artists. Lawrence Binyon, one of his admirers, has said that Blake took no interest in the human body; but how is this to be squared with the fact, so aptly pointed out by Paul Jamot, that Blake's work literally teems with representations of the human body? Surely here is an anomaly that justifies our questioning Blake's claim to be a painter as well as a poet.

There is no less discrepancy between his precept and his practice. To his mind the artist was the noblest type of man and, *ex officio* so to speak, a prophet. Yet, when this prophet expressed himself in painting, he fell into a style at once turgid and over-emphatic, rife with commonplaces. After examining a collection of his works, how refreshing it is to turn to the canvases of the Douanier Rousseau with their delightful candor and spontaneity.

Moreover, I am inclined to think that, by describing himself as a prophet, Blake renounced any claim to being an artist. For a prophet is essentially a man with a message; all that matters is what he tells us, and *how* he tells it is of minor importance. For the artist on the other hand (and this is what distinguishes him from the thinker) it is his way of expressing himself that matters. Thus Chardin is a very great painter; but if we wish to ask ourselves what his message was, the answer is simply—nothing at all. Vermeer painted Dutch housewives going about the most trivial daily tasks; other Dutch painters show us the same housewives, the same scenes. If Vermeer is far superior to them this is due to the *way* in which he painted; which is why, after Rembrandt, he is the greatest artist of his race.

Quite often, I admit, we find attractive harmonies of lively colors in Blake's paintings (the medium he used, watercolor and tempera, favored these), but his color never has any connection with his form; thus Blake's art is manifestly deficient in what are two essentials in every great artist's work: coherence and homogeneity.

He was a passionate admirer of Gothic art and made a number of drawings of mediaeval sculpture; for this reason many critics have been at great pains to detect the 'Gothic spirit' in his work. Apart from the fact that it is next to impossible to define what is meant by the 'Gothic spirit'—a term which would, presumably, have to embrace works as widely different in character as the Royal Portal of Chartres and the Mourners of the Burgundian tombs—I must admit my inability to discern the least connection between Blake's art and Gothic painting and sculpture.

How, then, should we appraise his work? It was a symptom, a sign of the times, far more than an achievement of creative art. Blake and Fuseli are to be set down among those artists who, although conscious of the new ideas that are 'in the air,' lack the artistic capacity needed for expressing them. They are like the soldiers of fortune who boldly force their way into uncharted lands but bring back scrappy,

inaccurate maps and travelers' tales which are a mixture of puerile misunderstandings and downright errors. As for Fuseli, today we can hardly take quite seriously those lurid imaginings of his which chilled the blood of his contemporaries. They fall in line with the terror-romantic literature of the age, the novels of 'Monk' Lewis, Maturin and Anne Radcliffe. When they fail to make us laugh, they make us yawn and, in fact, seem very small beer when compared to *The Postman Always Rings Twice* and Dashiel Hammett's thrillers. The mysticism of Blake's pictures is as dull and unrewarding as Ossian's poems or Young's *Night Thoughts*: the delight of our forefathers, but almost unreadable today.

Born at Zurich in 1741, Fuseli saw much of such writers as Breitinger and Bodmer who were frequent visitors at his father's house, and he became imbued with their ideas. In 1763, after a stay in Berlin, he went to London with the avowed intention of acting as a sort of liaison officer between the German and English writers of the day. He wrote as much as he painted and translated Winckelmann's treatise on ancient art. On Reynolds' advice he went to Italy to study art (in 1770) and there he met David, Mengs and Winckelmann and, as might be expected, developed a vast enthusiasm for Michelangelo. Back in London, he was soon busy producing large-scale canvases on themes taken from Shakespeare, the Bible, the Nibelungenlied and the Eddas; also he illustrated Milton, Homer and Wieland's *Oberon*. He had much success, was appointed professor of painting at the Royal Academy and exercised considerable influence. He died in 1825 at an advanced age.

Fuseli's ambitions, as we shall presently see, exceeded his capacities. Despite his limitations, however, he played an important part in the history of European art; indeed he figured in the vanguard of that vast aesthetic movement which, taking form at the end of the 18th century and grouping under one flag a host of painters, architects and writers, ushered in Romanticism.

We are, perhaps, too much dazzled by the charm of 18th-century French art to realize that this same century sponsored a rising tide of revolt against it, a revolt whose consequences were to be far-reaching. From 1730 onwards there developed, in Germany and England, a strong opposition to French art which for a hundred years had been paramount in Europe. That ultra-refined, amiable and aristocratic art had to be swept away; there was to be a return to the simple and natural, the primitive and grandiose. Thus the rights of nature and the imagination, and the autonomy of individual genius, were exalted at the expense of the set rules of the pontiffs of high art. The French classics of the 17th century and the paradigms of classical antiquity now gave precedence to the primitive epics, such as the Nibelungenlied and the Eddas, to which were added Homer (at long last understood!), Dante, Shakespeare and Milton.

The initiators of the movement were Swiss, Bodmer and Breitinger of Zurich, that is to say Fuseli's mentors. Their theories tallied with those put forward shortly afterwards by several Englishmen: Young, Blair, and Collins. In 1750, with his famous lecture at the Academy of Dijon, Jean-Jacques Rousseau gave them indirect support.

In 1755, the year that saw the publication of Winckelmann's great work on the art of antiquity, a Genevese writer, Mallet, brought to light the early poetic sagas of the Scandinavian races. From this time on the movement gathered such impetus that we can mention only its most striking manifestations: the poems of Ossian and Chatterton, Wieland's translation of Shakespeare into German, Herder's theories, the works of the Swiss aestheticians Sulzer and Merian, Blake's poetry, his pictures and engravings, Fuseli's writings and paintings. This ferment of activity was in fact a reaction of the 'natural' man against the sophisticated, conventionalized man; of the free-ranging genius against all rules; of sensibility and the imagination against Reason; of the North against the South. This reaction, it is true, made itself felt much more in literature than in the plastic arts, and for obvious reasons. Writers had at hand all the precedents they needed, from the Eddas up to Milton, whereas the plastic arts of the period preceding the Renaissance were not only little known, but still extremely

HENRY FUSELI (1741-1825). THE
NIGHTMARE, 1781. (30 × 25″)
PRIVATE COLLECTION, OBERHOFEN
SWITZERLAND.

difficult to evaluate. To an artist schooled in 18th century culture, during a period when all men of taste, of whatever outlook, were unanimous in their admiration of the Medicean Venus and the Apollo Belvedere, 14th- and 15th-century paintings could seem little more than clumsy daubs. Thus it was that artists like Blake, Fuseli and the German Carstens turned to Michelangelo, whilst others —Mengs, David, Flaxman and Canova—took their lead from ancient art, that is to say from Greek and Roman sculpture.

Fuseli, as much a man of letters as an artist, could not paint by instinct and seems to have set himself an aesthetic program summed up in his own words: "What is needed is a grand, sublime style, in which beauty is but the handmaid of grandeur." An excellent formula and one which promised well; unfortunately, Fuseli did not abide by it, or, rather, his notion of grandeur took a peculiar form.

A large number of his gigantic canvases, whose subjects are drawn from poetry, show us herculean figures with bulging muscles, gesticulating like madmen before dark backgrounds. There is nothing original in his technique; Fuseli merely took over the procedures which the English painters of his time had inherited from Van Dyck and adapted them to his own ends. On to this Flemish method of painting he grafted a draftsmanship obviously inspired by Michelangelo—but a Michelangelo that only

existed in the minds of Fuseli and Blake. Neither of them ever grasped the true spirit of Michelangelo's art; all they did was to reiterate his exaltation of the forms of the human

body but exaggerating this and draining it of all spiritual substance. They converted what had been for Michelangelo no more than a means of expression into the supreme object of their art. Though the figures peopling the Sistine Chapel belong to a race transcending the human, they are rooted in reality and one feels that Michelangelo's Adam and Eve, though built on an heroic scale, are real people, who breathe and eat and digest their food like the people we pass daily in the street. But Fuseli's figures are grandiloquent mannequins and remind us far less of those melancholy giants in the Sistine Chapel than of the Pergamene reliefs. They lack that vital contact with reality which those great visionaries Tintoretto, Rembrandt and El Greco were careful to maintain.

Fuseli, in fact, fell into the same error as Gustave Moreau. Instead of taking nature as his starting-point and building

FRANCISCO DE GOYA Y LUCIENTES (1746-1828). SAINT FRANCIS BORGIA AND THE DYING IMPENITENT, 1788. CATHEDRAL, VALENCIA.

up from it a world of his own he made works of art his starting-point. C. F. Ramuz once remarked that it is impossible to create works of art by reference to previous works of art: a dictum that is certainly too sweeping though it has much truth in it. Poussin was perfectly successful in creating very fine works, using the sculpture of antiquity as his taking-off point; nevertheless he vivified them with his love of nature, landscape and the human body. It was quite otherwise with Fuseli; he loses touch with nature all too often and when he recognizes that a visible world exists, it is only to turn his eyes towards the stage. Judging by his declarations, we might expect of Fuseli simple, unaffected, almost primitive works, very near to nature; actually when he seeks to conjure up the world of sagas and ancient legends he shows us Kriemhild, the Sultana Almansaris and Thetis tricked out like actresses of the contemporary London stage with elaborate coiffures, and wearing scarves, pearl necklaces and turbans. Even the fairies of the Midsummer-Night's Dream whose very names are racy of the woodlands, meadows, even of the vegetable-garden—Peaseblossom, Cobweb, Moth and Mustardseed—appear in Fuseli's pictures wearing plumed toques on their fashionably dressed hair and in suggestive décolleté.

The truth is that there were two Fuselis: the Fuseli who, following Michelangelo, was all for the grandiose and the high fantastic, and the other Fuseli who enjoyed painting the fashionable beauties of the day. Hence the oil paintings, watercolors and drawings stamped with a voluptuous mannerism in which the sinuous poses and elongations of the figures, combined with an exquisite artificiality, recall at once Primaticcio and Rosso, Bakst and Aubrey Beardsley. This will seem less surprising when we remember the fact that from Michelangelo there stemmed a lineage of artists (Parmigiano, Pontormo, Ammanati, the Baroque and Rococo Austrian sculptors) who sedulously 'feminized' and daintified his figures. This unexpected (and not unattractive) aspect of Fuseli's art seems to indicate that he was much influenced, especially in his large pictures, by the stage decoration of the period and, in a general way, by the optics of the theater; and also that, like Reinhardt and Bakst, he was born to be a theatrical producer and decorator rather than a painter.

During this period there came upon the scene a truly great painter whose art miraculously combined the spirit of the 18th and that of the 19th century; I am referring, needless to say, to Goya—that "great lover and great hater" as Baudelaire aptly described him. For Goya was a voluptuary who, whenever he did not lapse, *à la Greuze*, into sentimentality, was always tending towards cruelty. Setting as it did much store on the satisfaction of physical desire, the 18th century inevitably led up both to Sade and to Bernardin de Saint-Pierre, to *Justine* and to *Paul et Virginie*; and there is more kinship between these works than is apparent at first sight. Goya was satisfying his desires no less when he painted scenes of carnage and horror than when he stressed the charms of the *Nude Maja* or those of the *Marchioness Espejo*.

It seems clear from his depictions of Witches' Sabbaths, sorceresses and specters that—almost, one might think, telepathically—he had sensed the swing-round to Romanticism impending in the North. A strong 'liberal,' and a devotee of the

Enlightenment, Goya had dealings only with the dark side of mysticism, indeed its caricature: Satanism and sorcery. Averting his gaze from heaven, he saw only the hags and ghouls of the underworld and their lord, the Arch-Deceiver, in the form of an enormous he-goat. It is this curious dualism of rationalism and occultism that imparts to Goya's art its curious vibrancy—like the "quivering of a leaf" that Gœthe deemed so essential for the work of art—and gives it its singular fascination. While, Tiepolo notwithstanding, painting was growing ever more fossilized in Italy (for this Mengs and Winckelmann were to blame), was being scaled down to the bourgeois level in France (for this David was responsible) and becoming more and more platitudinous in England despite the misguided efforts of Blake and Fuseli, Goya in Spain fanned the sacred fire and won a high place in the lineage of genius. Sensual as Fragonard and Casanova, bitingly satirical as Voltaire and Chamfort, he is the last, most dazzling luminary of that great age of the Enlightenment.

But, more than this, he paved the way for the art of the 19th century. Wholly unaffected by the pseudo-antique art so competently turned out by David, Canova and Flaxman, he anticipated both the discoveries of those fine colorists Delacroix, Turner and Renoir, and the work of the great painters of the manners of their age, Daumier, Degas and Lautrec. He heralded the triumph of that personal, free, elliptic idiom in painting which culminated with Impressionism.

The circumstance that Goya's art straddles as it were two centuries is no less apparent in his drawings and engravings. While his studies in sanguine and his etchings often recall Watteau, Fragonard and Tiepolo, a good many of them—and especially his pen-and-ink drawings, at once concise and cursive—might well be by the hand of a contemporary of Delacroix or Manet.

It has often been said that the plays of the 18th-century writer, Beaumarchais, anticipated the spirit of the 19th century. Might we not say of Goya's art that it is in some respects a somber version of Beaumarchais' witty comedy *Le Mariage de Figaro*? The half-innocent sensuality (how well Goya could have painted Cherubino's portrait!) and "subversive tendencies," politically speaking, of the play—Napoleon characterized it as "the Revolution already in action"—its social satire, its intermingling of the aristocracy with picturesque representatives of the common people—all these qualities are equally present in Goya's art.

But—and this is the essential difference between Goya and Beaumarchais—Goya's art ranges farther and he has a profounder insight into the human heart. Though in many respects a precursor, Beaumarchais only gave glimpses of the mentality of the coming century; we do not feel him very near to us, as Goya always is. For besides being the last in date of the great painters of the past, Goya strikes us as almost our contemporary, and when, after seeing in the Prado the canvases of El Greco, Titian, Rubens and Velazquez, we enter the Goya rooms, the gap of a century and a half is forgotten, we feel ourselves in a familiar climate. "Here," we think, "is a man who speaks the same language as ourselves." Indeed I would go so far as to say that we feel more at home with Goya than with Delacroix or even Daumier.

BIOGRAPHICAL AND BIBLIOGRAPHICAL NOTICES

AVED, JACQUES.

Born at Douai in 1702, son of a doctor. After spending his youth at Amsterdam, he came to Paris in 1721 and was received at the Academy in 1734. In 1738 he went to Brussels to paint the portrait of Jean-Jacques Rousseau. A collector and dealer as well as a painter, Aved left a large collection of pictures at his death in 1766.

Bibl.: G. WILDENSTEIN. *Aved*. Paris 1922.

BATONI, POMPEO.

Born at Lucca in 1708, he worked at Rome with Sebastiano Conca and assiduously studied ancient art and Raphael's works. He painted pictures on religious and mythological themes, as well as portraits, best known of which are those of several Popes and of the Emperors Joseph II and Leopold II. Highly esteemed in his day, he never lacked commissions and held the post of Keeper of the pontifical collections. Died in 1787.

BELLOTTO, BERNARDO.

Born at Venice in 1720, he worked under his uncle, Canaletto, who urged him to go to Rome and study Pannini's works, which he did. Invited to Dresden in 1747, he remained there until 1758; then moved to Vienna where he lived until 1762. Next worked in Warsaw and St Petersburg. Coming back to Warsaw, he was appointed King's Painter by Stanislas Augustus, King of Poland, and died in that city in 1780. Besides his urban landscapes, so strongly influenced by Canaletto, he made some very fine etchings.

BLAKE, WILLIAM.

Born in London in 1757, the son of a hatter. As a child he showed a precocious talent for drawing and in 1771 was apprenticed to an engraver, James Basire, who set him to drawing the Gothic monuments at Westminster Abbey. At twenty-one he began earning his own living as an engraver, working some twenty years for various publishers. Among his friends were Flaxman and Fuseli, both of whom influenced him. In 1782 he married Catherine Bouchier, a gardener's daughter, his devoted helpmate to the end of his days. From 1787 on he published his poems; both text and illustrations were engraved by him according to a process allegedly revealed to him in a vision. Next he colored the illustration by hand. He made his large colored prints round about 1795, and two years later 537 watercolors for Young's *Night Thoughts*. It was largely through the generous aid and encouragement of Captain Butts that he was able to carry on at this time. However, from 1800 to 1803 he was compelled to work for Haylay, a publisher with whom he was constantly at odds. Back in London, he devoted himself heart and soul to his own creative work in the hope of at last securing some success and recognition. But it was not to be, and Blake passed through a critical period of poverty and depression. An exhibition of his works, held in 1809 at his brother's house, passed almost unnoticed; the solitary article published regarding the exhibition heaped ridicule upon his work. During the following years he lived in such seclusion that little is known of his activities. Though most of his contemporaries regarded him as a crank or a madman, he enjoyed during his last years relative calm and serenity thanks to the homage paid him by a group of younger artists. In 1821 he began a series of illustrations for the *Book of Job*, following up with a hundred watercolors for Dante's *Divine Comedy*. Seven of them had been engraved when Blake died on August 12, 1827.

Bibl.: L. BINYON. *The Drawings and Engravings of William Blake*. London 1912. — L. BINYON. *The Engraved Designs of William Blake*. London 1925. — PH. SOUPAULT. *William Blake*. Paris 1929. — ARTHUR SYMONS. *William Blake*. London 1907. — D. FIGGIS. *The Painting of William Blake*. London 1925.

BONITO, GIUSEPPE.

Born at Castellamare in 1707, he studied under Solimena. He was appointed Painter to the King's Household by the King of Naples in 1751, then director of the Academy of Drawing and the tapestry factory (in 1755) and died in 1789. He began by painting frescos and pictures on religious themes; then turned exclusively to scenes of contemporary life.

BOUCHER, FRANÇOIS.

Born in 1703, son of a maker of embroidery designs. As a boy he worked under his father; then, after an apprenticeship with the engraver Cars, he became Lemoyne's pupil. He was deeply influenced by that master, though he later claimed to have stayed only three months with him. He went to Italy in 1727, where he diligently studied Pietro da Cortona and the Venetians. Back in Paris he turned out a great many pictures, prints and illustrations for books. In 1733 he married a pretty seventeen-year-old girl, Marie-Jeanne Busseau, and in 1734 was received at the Academy. A protégé of Madame de Pompadour, he became Court painter and drawing-master and was showered with commissions. These included decorative paintings, tapestry cartoons, projects for the manufacture of Sèvres and Vincennes porcelain, sets for Monnet's Théâtre de la Foire Saint-Laurent, and even puppet costumes. He was also given commissions for portraits, among them being seven of Madame de Pompadour, one of which is in pastels. After working at the Beauvais tapestry factory, he succeeded Carle Vanloo in 1765 as art director of the Gobelins factory. A rich, successful artist, owning a very valuable collection of paintings, drawings, minerals, shells and precious objects, he seemed to have everything a man could desire. His only trouble was that he felt his popularity waning. Nevertheless he made no effort to change his manner. He was still actively working when he died on May 30, 1770.

Bibl.: EDM. and J. DE GONCOURT. *L'Art du dix-huitième siècle*. Paris 1859-1875. — H. MACFALL. *Boucher*. London 1908. — A. MICHEL. *Boucher*. Paris 1908. — P. DE NOLHAC. *Boucher*. Paris 1907.

CANALETTO, ANTONIO CANAL, known as.

Born in 1697 at Venice, the son of a scene-painter, Bernardo Canal; he assumed the name Canaletto to prevent his being confused with his father. A pupil first of his father, then of Carlevaris, he went to Rome to study the ancient ruins. About 1719 he began to paint views of Venice and the lagoon. His pictures became very much sought after, especially in England; he stayed in London from 1747 to 1754 or 1755, then returned to Venice, where he died in 1768. Besides his landscapes, he did some excellent etchings.

Bibl.: R. MEYER. *Die beiden Canaletto*. Dresden 1878. A. MOUREAU. *Antonio Canal dit le Canaletto*. Paris 1894. O. UZANNE. *Les deux Canaletto*. Paris 1906. — G. FERRARI. *I due Canaletto: Antonio Canal, Bernardo Bellotto, pittori*. Turin 1914. — F. H. FINBERG. *Canaletto in England*. Oxford 1921.

CARLEVARIS, Luca.

Born at Udine in 1665, he went to Rome to paint the remains of classical antiquity. At the beginning of the 18th century, he returned to Venice and his views of the city enjoyed great success. Died in Venice, 1731.

CARRIERA, Rosalba.

Born at Venice, she studied pastel and miniature-painting under various masters. She became famous throughout Europe as a pastellist, and was given a triumphal reception in Paris in 1720. After a short stay at Vienna in 1730, she never left Venice again. Towards the end of her life she went blind and lost her mind. Died in 1757.

Bibl.: A. Sensier. *Rosalba Carriera.* Paris 1865. — E. Hoerschelmann. *Rosalba Carriera, die Meisterin der Pastellmalerei*, Leipzig 1908. — V. Malamani. *Rosalba Carriera.* Bergamo 1910.

CERUTI, Giacomo.

Little is known about this artist, said by some to have hailed from Milan, by others from Brescia. He was born towards the middle of the 18th century; works by him can be seen at Padua and at Brescia. Though he painted some religious pictures, his best works are portraits and scenes of the everyday life of the people.

CHARDIN, Jean-Baptiste Siméon.

Born in Paris in 1699, son of a joiner who made billiard-tables for the King. He studied first under Cazes, an indifferent painter, then under Noël Coypel, who directed his eyes to nature. He began by painting a sign for a surgeon-barber, then took to still lifes as a source of livelihood. In 1728, at the Place Dauphine, where the young artists of the day exhibited their works on Corpus Christi Day he showed several still lifes, among them *The Skate* (now in the Louvre), which attracted some attention. That same year he was admitted to the Academy, and in 1731 married Marguerite Saintard who, after bearing him a son and a daughter, died in 1735. From 1739 on, as a result of a slighting remark made by Aved, his friend and colleague, he turned to painting genre pictures. In 1744 he married Marguerite Pouget, widow of a musketeer, Charles de Malnoé. In his declining years he suffered greatly from gall-stones. Lacking the strength to work in oils, he turned to pastels, as being a quicker and easier medium. From 1771 he exhibited portraits and head-studies in pastel which met with much success. Chardin died on December 6, 1779.

Edm. and J. de Goncourt. *L'Art du dix-huitième siècle.* Paris 1859-1875. — Gaston Schéfer. *Chardin.* Paris 1904. Edmond Pilon, *Chardin.* Paris 1911. — Tristan Klingsor, *Chardin.* Paris 1924. — Georges Wildenstein, *Chardin.* Paris 1933.

CONCA, Sebastiano.

Born at Gaete in 1679. Studied under Solimena and worked at Rome. His large-scale decorations and his religious and mythological pictures were in great demand. Died at Naples in 1776, almost a centenarian.

COYPEL, Antoine.

Born in 1661, son of the painter Noël Coypel. When he was eleven he was taken to Italy by his father, who had been appointed director of the French Academy in Rome. His talent ripened quickly and he became an academician at the early age of twenty. In 1700 the Dauphin commissioned him to make decorations for the Château de Meudon. A favorite of the Duc d'Orléans, he was asked to paint the large gallery of the Palais-Royal in 1702, and in 1709 the vault of the chapel of the Château de Versailles. Died in 1722.

CRESPI, Giuseppe Maria, Lo Spagnolo.

Born at Bologna in 1664, he worked under various masters, but particularly studied the works of Guercino. He founded a bottega in which Piazzetta and Pietro Longhi worked for some time. Died at Bologna in 1747.

Bibl.: H. Voss. *G. M. Crespi.* Rome 1921.

CROME, John, known as "Old Crome".

Born at Norwich in 1768, the son of a weaver, he was apprenticed to a house-painter. By the good offices of a rich patron he was enabled to set up as a drawing master and founded the Norwich Society of Artists. He devoted himself almost wholly to landscape, exhibiting at the Royal Academy for the first time in 1806. He also did a great many etchings. Died at Norwich in 1821.

Bibl.: H. M. Cundall. *The Norwich School.* 1920. — C. H. C. Baker. *Crome.* 1921.

DAVID, Jacques-Louis.

Born in Paris in 1748, the son of a haberdasher. A pupil of Vien, he won the Prix de Rome in 1774 after failing several times. Going to Rome he came under the influence of Quatremère de Quincy, who oriented him towards ancient art. Returning to Paris he was widely acclaimed for his *Belisarius* (1781). He married in 1782 and went back to Rome where he finished his *Oath of the Horatii.* This work was hailed with enthusiasm at the 1785 Salon, as was his *Death of Socrates* (1787) and his *Oath of the Jeu de Paume* (1791). In 1792 he was made a member of the Convention and voted for the execution of the King. An ardent supporter of Robespierre, he spent several months in prison when that tyrant fell. Appointed a member of the Institute, then first painter to Napoleon, he became official painter to the Empire and was ennobled. Upon the Bourbon restoration he fled to Brussels, where he died in 1825.

Bibl.: L. Rosenthal. *David.* Paris 1904. — Cantinelli. *David.* Paris 1930.

DESPORTES, François.

Born in 1661 at Champigneulles in Champagne, the son of a farmer. He came to Paris at the age of thirteen; after taking lessons from Nicasius, a Flemish artist, he began painting decorations and theatrical scenery. Invited to Poland in 1695, he made a number of portraits there. Back in France the following year, he became Painter of the Royal Hunts and was admitted to the Academy in 1699. He visited England in 1712. Died in 1743.

DUPLESSIS, Joseph-Siffred.

Born at Carpentras in 1725, he went to Rome in 1745 where he became friendly with Subleyras and Joseph Vernet. He returned to France in 1749 and in 1752 to Paris, where he soon made his name as a portrait-painter. He was admitted to the Academy in 1774. Upon the outbreak of the Revolution he defended the Academy; reduced to poverty, he retired to Carpentras in 1792. After his return to Paris in 1796, he was appointed Keeper of the Museum of Versailles and died in 1802.

FRAGONARD, Jean-Honoré.

Born at Grasse in 1732, the son of a haberdasher. When the family moved to Paris, the boy became an apprentice-painter first with Chardin, then with Boucher. He won the Prix de Rome in 1752, but did not leave for Italy until

four years later. At Rome he made many copies and painted in company with Hubert Robert and the Abbé de Saint-Non. The latter took him to Naples, Bologna and Venice where the young painter made a special study of Tiepolo. Returning to Paris, he created a sensation at the 1765 Salon with *The High Priest Coresus sacrificing himself for Callirrhoe*. He realized, however, that he was not cut out for this kind of painting and began doing the discreetly erotic pictures which soon brought him fame and success. He also undertook decorative work, notably for Madame du Barry and for La Guimard, the famous dancer, with whom he ended up by quarrelling. In 1769 he married Marie-Anne Gérard, Provençal, like himself, and settled at Vaugirard, then a village on the outskirts of Paris. There he settled down to a quiet but industrious life with his wife, herself a miniature-painter, and her sister, Marguerite Gérard, also an artist. In 1773 Fragonard and the two ladies were invited on a trip to Italy by Bergeret de Grancourt, a wealthy financier. During the tour Fragonard made a great many sketches; these the financier claimed as Fragonard's share of the expenses, but he refused to give them up. A lawsuit followed which the artist won. The Revolution cut short his career and reduced him to poverty. A friend offered him shelter at Grasse and he was constrained to accept the offer. When at last he saw Paris again, he was a tired old man, broken in health and spirit, ill at ease and out of his element in a world changed out of recognition. He died in the summer of 1806.

Bibl.: EDM. and J. DE GONCOURT. *L'Art du dix-huitième siècle*. Paris 1859-1875. — C. MAUCLAIR. *Fragonard*. Paris 1913. — G. GRAPPE. *Fragonard*. Paris 1923. — P. DE NOLHAC. *Fragonard*. Paris 1931.

FUSELI, HENRY.

Born in 1741 at Zurich, where his family had been goldsmiths or casters of bells and cannons for over 400 years. The critics Breitinger and Bodmer were frequent visitors at his father's house and he soon imbibed their literary theories. Having had a hand in a lampoon aimed at one of the local dignitaries, he had to leave for Berlin. Thence he went to London where he translated Winckelmann, published a defence of Rousseau, and took to painting. He showed some of his work to Reynolds, who encouraged him to go to Italy. At Rome Fuseli studied Michelangelo and became friendly with David and Winckelmann. Back in London, he painted huge pictures on subjects taken from early sagas and epics, and from the great poets: Dante, Milton and Shakespeare. These had great success and he was hailed as the painter Romanticism had been waiting for. He was elected to the Royal Academy in 1790 and eight years later was appointed art-instructor there. He married an Englishwoman, Sophie Rawlins, one of whose tasks it became to smooth over the rash outbursts of her husband, notorious for his bluntness of speech and bad manners. Fuseli was over eighty when he died, in 1825.

Bibl.: A. FEDERMANN. *J.-H. Füssli*, Zurich 1927. — P. GANZ. *Die Zeichnungen Joh.-H. Füssli's*. Basel 1928. — EDM. JALOUX. *J.-H. Füssli*. Montreux 1942. — N. POWELL. *The Drawings of Henry Fuseli*. London, 1951. — E. C. MASON. *The Mind of Henry Fuseli*. London 1951.

GAINSBOROUGH, THOMAS.

The son of a wool-manufacturer, he was born in 1727 at Sudbury, in Suffolk, the youngest of a family of nine children. He spent his boyhood roaming the countryside, sketching the trees and cottages in the neighborhood of Sudbury and finally his father consented to his going to London to study painting and engraving. Back at Sudbury in 1745, he married Margaret Burr and settled at Ipswich, where he set up as a portrait-painter, occasionally painting landscapes for his own pleasure; he was also fond of music, and proficient on the violin. A dilettante, Philip Thicknesse, who had gotten some commissions for him, urged him to move to Bath, then a fashionable health-resort. Gainsborough settled there in 1759 and soon made a great name for himself. It was not long before he began sending in portraits and landscapes to the exhibitions held annually in London. In 1774 he moved to the capital where his success continued unabated. Not only the most famous men and women of the time, but the royal family were set on having him to paint their portraits. In 1768 he had been chosen as one of the foundation members of the Royal Academy. He sent in portraits and landscapes each year, but in 1783, dissatisfied with the position in which his portrait of the three princesses had been hung, he withdrew from the exhibitions, showing his work thereafter at his own house, but with less success. He died on August 2, 1788.

Bibl.: SIR W. ARMSTRONG. *Thomas Gainsborough*, 1904. — MRS ARTHUR BELL. *Thomas Gainsborough*. 1902. — W. T. WHITLEY. *Thomas Gainsborough*. 1913.

GHISLANDI, VITTORE, known as Fra Galgario.

Born in 1655 at Bergamo, where he studied painting. He then spent thirteen years at Venice, making himself familiar with the works of the great 16th-century masters. He studied for twelve years under Bombelli, a famous portraitist of the day, then under Salomon Adler at Milan. Returning to Bergamo, he worked chiefly as a portrait-painter. At the age of twenty, while at Venice, he took holy orders, changed his first name from Giuseppe to Vittore and adopted the surname Galgario after the convent where he lived in Bergamo.

Bibl.: V. BERNARDI. *Il pittore Fra Vittore Ghislandi*. Bergamo. 1910.

GILLOT, CLAUDE.

Born at Langres in 1673. He specialized in drawings and paintings on themes inspired by the Italian comedy. He died in 1722, ruined by the financial ventures of the famous John Law.

Bibl.: V. POPULUS. *Claude Gillot*. Paris 1930. — J. POLEY. *Claude Gillot*. Würzburg 1938.

GREUZE, JEAN-BAPTISTE.

Born at Tournus in 1725, the son of a tiler. He studied for a time at Lyons under Gromdon, an indifferent painter, then went to Paris, where the painter Silvestre and the sculptor Pigalle encouraged his early efforts. His work soon caught the attention of La Live de Jully, a wealthy dilettante who began to take an interest in him. In 1755 his *Father explaining the Bible to his Children*, shown privately by La Live, was a great success; this was followed by public recognition when the picture was exhibited at the Salon the same year. Shortly afterwards Greuze made a trip to Italy; coming back, he painted Italian genre scenes, portraits and head-studies of women. At the 1761 Salon his *Village Betrothal* was brilliantly successful; Diderot praised it to the skies and for the next ten years enthusiastically championed his protégé. Greuze followed up with a long series of homiletic pictures which delighted a sentimental-minded public. In 1769 he made a bid for admission to the Academy as an 'historical painter' with his *Septimus Severus reproaching his son Caracalla for an attempt on his life*; but the work was very badly received by the Academicians and Greuze was apprised, to his disgust, that he was admitted only as a 'genre painter', then considered a much inferior category. As he was inordinately vain, this setback left him an embittered man. To add to his troubles, the unseemly behavior of his pretty wife, Anne-Gabrielle Babuty, obliged him to part with her. Withdrawing from the Salon exhibitions, he showed his work henceforth in his own studio,

to which the public flocked to see them. Thanks to the sale of his pictures and the prints engraved from them, he had amassed a considerable fortune; but the Revolution ruined him. He ended his days in extreme poverty, his one consolation being his daughter's devoted companionship. He died in 1805.

Bibl.: J. MARTIN. *Catalogue de l'œuvre de Greuze*. Paris 1809. — L. HAUTECŒUR. *Greuze*. Paris 1913.

GUARDI, FRANCESCO.

Born at Venice in 1712, he came of a noble family. His father, too, was a painter and Giambattista Tiepolo became his brother-in-law. He worked at Venice and his pictures were in great demand among foreign collectors. However, he was not admitted to the Academy of Painting until 1784, nine years before his death, in 1793.

Bibl.: G. A. SIMONSON. *Francesco Guardi*. London 1904. — P. PANIZZA. *Francesco Guardi*. Trento 1912. — G. DAMERINI. *L'arte di Francesco Guardi*. Venice 1912. — G. FIOCCO. *Francesco Guardi*. Florence 1923.

HOGARTH, WILLIAM.

Born in London in 1697, the son of a schoolmaster. He took to drawing at an early age, was apprenticed to a silversmith and began engraving on copper about 1720. In 1724 he published his first engravings and soon made a name for himself with his illustrations for Samuel Butler's *Hudibras*. He then made small group portraits, 'conversation pieces,' and in 1731 finished *The Harlot's Progress*, his first series of satirical paintings. This met with great success and he followed it up with *The Rake's Progress*; but it was the engravings he later made from these paintings, rather than the paintings themselves, that met with general acclaim and became so popular. He was much sought after as a portraitist; his attempts to create a market for his pictures on Biblical themes were, on the other hand, quite unsuccessful. The *Marriage à la Mode* series (at the National Gallery, London) was regarded as his masterpiece. In 1753 he published a treatise on aesthetics, *The Analysis of Beauty*, which today is no more than an interesting curiosity. He was appointed Serjeant Painter to the King in 1757 and carried on a prolonged controversy with his former friends John Wilkes and Churchill. Hogarth died in 1764.

Bibl.: A. DOBSON. *Hogarth*. London 1904. — F. BENOÎT. *Hogarth*. Paris 1905. — F. ANTRAL. *Hogarth*. Paris 1931.

JEAURAT, ETIENNE.

Born in 1699, he went to Rome in 1724. He left works on religious and mythological themes and genre scenes of the life of the people. He was admitted to the Academy in 1733 and died in 1789.

JOUVENET, JEAN.

Born in 1644 at Rouen, he worked in Le Brun's studio but never made the trip to Italy. Though he painted a few portraits, his speciality was large-scale pictures on religious themes. He became partially paralysed in 1713 but continued to paint with his left hand. Died in 1717.

LA FOSSE, CHARLES DE.

Born in 1636, he studied in Italy, spending two years in Rome and three at Venice. He next went to England where he stayed from 1689 to 1692 and painted three ceilings in Lord Montagu's residence, now the British Museum. It seems that Mansart, architect of the Invalides in Paris, originally wanted him to carry out the entire decoration of the Invalides chapel; but in the end La Fosse painted only the dome and the pendentives. He then did a number of paintings for Pierre Crozat, the well-known collector, who introduced him to Watteau; the two painters became close friends. La Fosse died in 1716.

LANCRET, NICOLAS.

Born in Paris in 1690, the son of a coachman. After studying at the Academy, he entered Gillot's studio. This he left to work with Watteau, who advised him to paint from nature. Lancret's pictures were highly thought of and bought for the greatest collections in Europe. He also left several decorative works. He became an academician in 1719 and died in 1743.

Bibl.: G. WILDENSTEIN. *Lancret*. Paris 1924.

LARGILLIERRE, NICOLAS DE.

Born in Paris in 1656. At the age of three he was taken to Antwerp where his father was in business. After staying in London from 1665 to 1667, he returned to Antwerp and then was in London again from 1674 to 1678, when he went back to France. He soon made a great name for himself as a portrait-painter, became an academician in 1686 and died in 1746.

LA TOUR, MAURICE-QUENTIN DE.

Born in 1704 at Saint-Quentin, where his father, after having been the trumpet-player in a military band, was cantor of the collegiate church. As a boy, La Tour was sent to Paris and apprenticed to the painter Jan Jacob Spoede. Coming back to Saint-Quentin, he had an affair with one of his cousins, the result of which was a still-born child. After a stay in London, he went again to Paris and began painting portraits in pastel. These were not particularly good; the painter Louis de Boullongne, after pointing out their faults, was good-natured enough to give him practical advice, which La Tour turned to good account, with the result that presently he made quite a name for himself. At the 1741 Salon his large portrait of President de Rieux was enthusiastically received, as were, the following year, his portraits of the President, Mademoiselle Sallé, Abbé Huber and the painter Dumont de Romain. From now on La Tour's reputation steadily rose; he was commissioned to paint the members of the royal family, and portraits from his hand were much sought after by the fashionable élite. But he also portrayed such outstanding personalities as Jean-Jacques Rousseau, d'Alembert, Duclos, the architect Gabriel, besides leading actors, actresses and dancers. He had always been self-assertive and now his success went to his head, and he became positively insolent in his dealings with his friends and patrons. For thirty years he was regarded as the first portraitist of the day. Only in 1773 did he begin to meet with opposition from critics, who accused him of spoiling his pastels, taking off their bloom, by excessive retouchings. La Tour carried on an affair for many years with Marie Fel, a well-known singer, a very fine portrait of whom is in the Museum of Saint-Quentin. In 1766 the artist traveled to Holland where he made a portrait of Mademoiselle de Tuyll, who later became Madame de Charrière. After 1770 he showed signs of being mentally unbalanced and in 1784 his brother had him declared incapable of managing his affairs. He died in 1788. In pursuance of La Tour's will and testament, his brother bequeathed to the city of Saint-Quentin all the works of art left to him by the painter.

Bibl.: EDM. and J. DE GONCOURT. *L'Art du dix-huitième siècle*. Paris 1859-1875. — M. TOURNEUX. *La Tour*. Paris 1904. — H. LAPAUZE. *La Tour*. Paris 1905. — H. LAPAUZE. *Les Pastels de La Tour à Saint-Quentin*. Paris 1919. — A. BESNARD and G. WILDENSTEIN. *La Tour*. Paris 1928.

LAWRENCE, SIR THOMAS.

Born at Bristol in 1769, the son of an inn-keeper, he showed as a child a precocious talent for drawing. In 1782 the family moved to Bath where the boy artist already began to get commissions. Going to London in 1787, he worked

at the Royal Academy and quickly made his name as a portrait-painter. He became King's Portrait-Painter-in-Ordinary on the death of Reynolds in 1792 and a member of the Royal Academy in 1794. His prestige was now immense and his reputation Europe-wide. Knighted in 1815, he went in 1818-1820 to Aachen, Vienna and Rome to paint the Allied Sovereigns and diplomats at the settlement of European affairs after the Napoleonic wars. He died in 1830.

Bibl.: Armstrong, Sir Walter. *Sir Thomas Lawrence.* London 1913.

LEMOYNE, François.

Born in Paris in 1688, the son of a postilion. He got off to a brilliant start, winning the Prix de Rome in 1711 and being received at the Academy in 1716. He made a great many church decorations; between 1732 and 1736 he painted the ceiling of the Salon d'Hercule at Versailles. He was then appointed King's Painter. In 1737, however, suffering from persecution mania, he committed suicide, stabbing himself nine times with his sword.

LÉPICIÉ, Nicolas.

Born in 1735 of parents who were both engravers. He studied under Carle Vanloo, but never succeeded in winning a 'first' in the Prix de Rome competitions. He tried his hand at many forms of art and his work brought him membership of the Academy in 1764. Towards the end of his life he fell into an extreme form of religious bigotry. He died in 1784.

LIOTARD, Jean-Etienne.

Born at Geneva in 1702, the son of a French businessman from Montélimar. In 1723, having already shown a remarkable talent for drawing, young Liotard went to Paris where he spent some time as a pupil of the painter and engraver Massé. He then left for Italy with the Marquis de Puysieux, French ambassador to the Holy See; they arrived in Rome in 1736. Two years later he set out for Constantinople in company with a young Englishman named Ponsonby, son of Lord Bessborough; they visited the chief seaports of the Levant and Liotard made many sketches of the inhabitants. At Constantinople he painted portraits and genre scenes in oils and pastel. In 1742 he traveled to Vienna, receiving a warm welcome from the Empress Maria-Theresa. As he now wore a beard and had adopted Oriental dress he became known as 'the Turkish painter.' In 1748 he went to Paris where his portraits, though obtaining a certain success, were criticized for not sufficiently flattering the model. Continuing his travels, he proceeded first to London, then to Holland where he married Mademoiselle Marie Fargues, daughter of a French businessman established at Amsterdam. He finally returned to Geneva and settled down there, henceforth making only brief trips to Vienna, Paris, London and Lyons. During the last thirty years of his life he specialized in pastel portraits of the Genevese social leaders and of ladies come from abroad to consult the celebrated local physician Dr Tronchin. Towards the close of his life he did some still lifes of flowers and fruit. He died in 1789 at the age of eighty-seven.

Bibl.: E. Humbert, A. Revilliod, J. W. R. Tilanus. *La vie et les œuvres de J.-E. Liotard.* Amsterdam and Geneva 1897. — D. Baud-Bovy. *Peintres genevois.* Tome I. Geneva 1903. — F. Fosca, *Liotard.* Geneva 1928. — L. Gielly. *L'Ecole genevoise de peinture.* Geneva 1935. — E. Gradmann and A.-M. Cetto. *Schweizer Malerei und Zeichnung im XVII. und XVIII. J.* Basel 1941. — F. Fosca. *Histoire de la peinture suisse.* Geneva 1946. — A. Bovy. *La peinture suisse de 1600 à 1900.* Basel 1948.

LONGHI, Pietro.

Born at Venice in 1702, he worked at Bologna under Crespi. After some early attempts at historical painting, he devoted himself entirely to painting scenes of contemporary life. He died in 1786.

Bibl.: A. Rava. *Pietro Longhi.* Bergamo 1922.

MAGNASCO, Alessandro, known as Il Lissandrino.

Born at Genoa ca. 1667, the son of a painter, Stefano Magnasco. He lived chiefly at Milan until 1735, worked for a time at Florence and died at Genoa in 1747.

Bibl.: C. G. Ratti. *Vita di Alessandro Magnasco, pittore.* Berlin 1914. — G. Beltrami. *Alessandro Magnasco detto il Lissandrino.* Milan 1913. — A. Ferri. *Magnasco.* Rome 1922. — B. Geiger. *Magnasco.* Vienna 1923.

MENGS, Anton Raphael.

Born in 1728 at Aussig (Bohemia), the son of a minor Danish painter who had settled at Dresden. His father took him to Rome in 1738 and set him to drawing from Raphael and the antique. Returning to Dresden four years later with his family, young Mengs, still only a boy, was named Court Painter to the King of Poland. He went back to Rome, got married and gained a certain renown by his conversion to Catholicism and the dexterity of his art. After another stay at Dresden, Mengs settled at Rome in 1751 where he began producing the large decorative frescos and pictures that brought him fame and success. He went to Madrid in 1774, staying three years and doing numerous portraits; then returned to Rome where he died in 1779.

MOREAU, Louis-Gabriel, The Elder.

Born in Paris in 1739, the son of a wig-maker. From 1774 on he painted a great many landscapes of the environs of Paris. He was twice refused admittance to the Academy and died in 1805.

Bibl.: G. Wildenstein. *Louis Moreau.* Paris 1923.

NATOIRE, Charles.

Born at Nîmes in 1700, the son of an architect and sculptor hailing from Lorraine. He went to Paris, studied under Lemoyne and won the Prix de Rome in 1721. He left for Italy and did not come back to Paris until 1728, being received at the Academy in 1734. He did a great many decorative paintings and in 1751 was appointed director of the French Academy in Rome. His incompetent administration giving rise to official enquiries, he withdrew to Castel Gandolfo, on the outskirts of Rome, where he died in 1777.

NATTIER, Jean-Marc.

Born in 1685, he began his career as a draftsman. In 1715, he was bidden to Amsterdam by the Czar. He then took to painting portraits and his depiction of his models as Greek gods and goddesses met with enormous success. By the end of his life, however, this vogue had passed and he died quite forgotten in 1766.

Bibl.: P. de Nolhac. *Nattier.* Paris 1905.

OUDRY, Jean-Baptiste.

Born 1686 in Paris, where his father was a gilder and picture-dealer. A pupil of Largillierre, he began as a portraitist, then turned to still lifes, and finally became best known as an animal-painter. He did a great many tapestry cartoons for the Beauvais factory, of which he was appointed director-general, and for the Gobelins, of which he became superintendent in 1736. He died in 1755.

PANNINI, Giovanni Paolo.

Born at Piacenza about 1691, he studied the drawings of the Bibienas and went to Rome while still a youth. He made his home and career there, dying in 1764 (or possibly 1768).

Bibl.: L. Ozzola. *Gian Paolo Pannini pittore.* Turin 1921.

PATER, Jean-Baptiste.

Born at Valenciennes in 1696, the son of a sculptor of whom Watteau painted a very fine portrait. Coming to Paris, he became Watteau's pupil, but this master was "too fussy to be able to bear with a pupil's shortcomings." During his last illness, however, Watteau, regretting his fit of ill-temper, called in Pater, gave him valuable instruction and asked him to complete the pictures he had left unfinished. An incurable hypochondriac, ever haunted by the fear of falling ill and lapsing into poverty, Pater worked like a man possessed and amassed a small fortune. This he was never able to enjoy, for he died at the age of forty in 1736.

Bibl.: M^me Ingersoll-Smouse. *Pater.* Paris 1928.

PERRONNEAU, Jean-Baptiste.

Born in Paris in 1715, he studied painting under Natoire and Laurent Cars. His first portraits in pastels—those of Madame Desfriches and of a small child—date from 1744. His candidature for the Academy was sanctioned in 1746, the subjects set for his reception being two oil portraits, one of the sculptor Adam the Elder and one of the painter Oudry. From this time on he exhibited portraits in oils and pastels regularly at the Academy, and his reputation was on a par with La Tour's. In 1753 he was nominated a full member of the Academy. In the following year he married Louise-Charlotte Aubert, daughter of an artist who did enamel-painting for the King. Throughout his career, in order to maintain a satisfactory income, Perronneau had to paint portraits in the French provinces, in Holland (where his work was particularly esteemed), in Italy and in England. After 1754 he made frequent trips to Holland; it was at Amsterdam that he died in 1783. A bare three months after his death, his wife, a consumptive, neurasthenic woman, married the painter Robin.

Bibl.: L. Vaillat and P. Ratouis de Limay. *Perronneau.* Paris 1909.

PIAZZETTA, Giovanni-Battista.

Born at Venice in 1682, the son of a wood-carver. He went to Bologna to study under G. M. Crespi, but also learnt much from the work of Guercino, Domenico Feti and Sebastiano Ricci. He died in 1754. His œuvre comprises pictures and frescos on sacred and profane subjects, portraits and etchings.

Bibl.: A. Rava. *Piazzetta.* Florence 1921.

PITTONI, Giovanni-Battista.

Born at Venice in 1687 into a family of artists. Though he traveled widely throughout Europe, his art is chiefly indebted to his compatriot, Veronese. He became president of the Venetian Academy of Fine Arts and died in 1767.

Bibl.: L. Pittoni. *G.-B. Pittoni.* Florence 1921.

REYNOLDS, Sir Joshua.

Born in 1723 at Plympton Earl in Devonshire. His father, a clergyman, saw to it that the boy received a sound education. At seventeen he was apprenticed to Hudson, a well-known portrait-painter. In 1748 Commodore Keppel, who had taken a liking to him and realized how beneficial a trip to Italy would be to him, offered Reynolds a free passage on his ship, the *Centurion,* to the Mediterranean. The cruise lasted no less than four years, years which the artist turned to good account, studying the works of the Italian masters and making many copies. He returned to London in 1752 and soon became the most fashionable portrait-painter of the day, showered with commissions. The high society of London, eminent writers and actors and even famous ladies of the town flocked to his studio in Leicester Square, seizing every opportunity to sit for him. In 1768 he became a foundation member of the Royal Academy; the same year he was appointed first President of the Academy and was knighted. In the course of his presidential duties he delivered the famous *Discourses;* the theories of art he preached in them were very different from those he had practiced. The *Discourses,* originally intended for the instruction of young artists, were subsequently published in book form. Regarded as the greatest of English painters, Reynolds averaged an income of some £6000 a year. In 1783 he had a stroke and six years later went nearly blind. He died in 1792.

Bibl.: Graves and Cronin. *A History of the Works of Sir Joshua Reynolds.* 4 vol. London 1899-1901. — Sir Walter Armstrong. *Sir Joshua Reynolds.* London 1900. — F. Benoit. *Reynolds.* Paris n.d. — A. Dayot. *Reynolds.* Paris 1930.

RICCI, Sebastiano (also known as RIZZI).

Born at Belluno in 1660, he studied at Milan, under Magnasco. After this he led a nomadic existence, working in various Italian cities, then in Germany, Flanders, France and England, until finally he returned to Italy, to die in Venice, in 1734.

Bibl.: J. Derschau. *Sebastiano Ricci.* Heidelberg 1922.

ROBERT, Hubert.

Born in Paris in 1733; his father was valet to the Marquis de Stainville, envoy of the Duke of Lorraine to the King of France. His father wanted him to make a career in the Church, but the boy's only interest was in painting. In 1754 the son of the Marquis, the Comte de Stainville, was appointed French Ambassador to the Holy See and took young Robert with him to Rome. There he sought out Pannini, was converted to his views and decided that he, too, would devote himself to painting the ruins of the past. In 1766 Fragonard arrived in Rome, struck up a friendship with Robert and the two young painters worked together in Rome and its environs. Shortly afterwards the Abbé de Saint-Non joined them and took Robert on a trip to Naples and Paestum. In 1765, at the age of thirty-two, he decided to return to Paris. There, drawing on his memory and the sketches he brought back from Italy, he painted landscapes associating scenes of contemporary life with settings of the ruins of antiquity. In 1783 he visited the south of France, and now the Maison Carrée and the Pont du Gard replaced the Coliseum and the Roman aqueducts in his pictures. He also painted views of the Park of Versailles, the monuments of Paris and, later, the leading events of the French Revolution. Upon his return from Rome he had been admitted to the Academy and his works were in great demand. During the Revolution, however, he was imprisoned for a time; he continued painting indefatigably in his cell. He was released when Robespierre fell from power. He made one more trip to Italy in 1802 and died in 1808.

Bibl.: P. de Nolhac. *Hubert Robert.* Paris 1910. — Tr. Leclire. *Hubert Robert.* Paris 1913.

ROWLANDSON, Thomas.

Born in London in 1756, the son of a shopkeeper. After studying at the Academy school, he went to Paris to work at the age of sixteen. He made his living as a caricaturist and illustrated many books. He died in London in 1827.

SOLIMENA, FRANCESCO.

Born in 1657 at Nocera de' Pagani, near Naples. He studied the work of Mattia Preti and Luca Giordano, and succeeded the last-named artist as accepted leader of the Neapolitan School. Died at Barra, near Naples, in 1743.

STUBBS, GEORGE

Born at Liverpool in 1724, the son of a currier. As a young man he devoted himself to portrait-painting and showed a nomadic turn of mind. In 1754 he went to Italy, struck up a friendship with a Moor and the two went to Ceuta together. He got back to London in 1756 and soon made his name as a painter of horses; in 1766 he published an illustrated book entitled 'The Anatomy of the Horse.' He also painted dogs and wild animals, and some enamel work by him on copper and pottery is extant. He exhibited at the Royal Academy for the first time in 1775; he died very suddenly in 1806.

Bibl.: GILBEY, Sir WALTER. *The Life of George Stubbs R.A.* London 1898.

SUBLEYRAS, PIERRE.

Born at Uzès in 1699, the son of a painter. After working at Toulouse he went to Paris in 1724. He won the Prix de Rome in 1727 and left for Italy in 1728. After spending seven years at the French Academy, he settled for good in Rome, where his work was highly esteemed and he received a steady flow of commissions for church pictures. He died in Rome in 1749.

TIEPOLO, GIAMBATTISTA.

Born at Venice in 1696; his father was the captain of a merchant ship. While still a boy he entered the studio of Gregorio Lazzarini. On November 21, 1719, he married Cecilia Guardi, sister of the landscape-painter Francesco Guardi; she bore him nine children. Two of them, Giandomenico and Lorenzo, became pupils of their father and assisted him in his decorations. His career went smoothly from the start and he was commissioned to do many pictures for churches and *palazzi* in Venice. His first important decorative work was at the Church of Santa Maria del Rosario, for the Order of the Jesuits, in 1737, and three years later he painted the ceiling of the Church of the Scalzi. As early as 1726, his reputation as a decorator having spread throughout northern Italy, he was called to Udine; he worked at Milan in 1731, at Bergamo in 1732 and 1733, at Vicenza and Milan in 1737, again at Udine in 1759 and at Verona in 1761. His two most important decorative works, however, he did abroad. In 1750 the prince-bishop Karl Philip von Greiffenklau commissioned him to paint the grand hall of his palace at Würzburg, and on its completion the prince-bishop was so pleased with Tiepolo's work that he had him paint the dome of the Grand Staircase. In March 1762, at the bidding of Charles III, King of Spain, Tiepolo went to Madrid with his two sons and painted the ceiling of the Throne Room in the Royal Palace. The King asked the artist to do seven pictures for the Church of San Pasquale at Aranjuez, and proposed to have him decorate the dome of the new chapel in the Palace of Aranjuez. But the artist died at Madrid in 1770.

Bibl.: F. H. MEISSNER. *Tiepolo.* Bielefeld 1897. — M. DE CHENNEVIÈRES. *Les Tiepolo.* Paris 1898. — P. MOLMENTI. *Tiepolo, la vie et l'œuvre du peintre.* Paris 1911. — G. FIOCCO. *Tiepolo.* Florence 1921. — TH. HETZER. *Die Fresken Tiepolos in der Würzburger Residenz.* Frankfort 1943.

TOCQUÉ, LOUIS.

Born in 1696, the son of a painter, he studied under Nattier. From 1730 onwards he made a name for himself as a portrait-painter, first of a middle-class clientèle, then of an aristocratic one. He entered the Academy in 1734 and was invited in 1756 to Russia, where he stayed two years. On his way back he spent several months in Sweden and Denmark. He died in 1772.

Bibl.: COMTE ARNAUD DORIA. *Tocqué.* Paris n.d.

TROY, JEAN-FRANÇOIS DE.

Born in 1679 in Paris. His family, originally from Toulouse, had many artists among its members. His father, a well-known painter, sent the boy to Italy at the age of fourteen; he stayed six years in Italy. After his return to Paris, he was given many commissions for decorative paintings and tapestry cartoons. On his appointment in 1738 as director of the French Academy, he went to Rome, where he met with great success. It came as a blow, however, when Natoire was sent to replace him as Director of the French Academy and he died of chagrin in 1752 on the eve of setting out for France.

VANLOO, CARLE.

Born in 1705 at Nice of a family that produced several artists, he was given early lessons by the sculptor Legros, in Rome. After winning the Prix de Rome in 1727, he returned to Rome accompanied by Boucher. His work met with much success in Italy and he was commissioned to decorate churches and palaces at Turin. Received at the Academy in 1735, appointed First Painter to the King in 1762, he enjoyed a vast reputation and was loaded with honors. He died in 1765.

VERNET, JOSEPH.

Born at Avignon in 1714, the son of a local painter. In his youth he gained a certain reputation at Aix-en-Provence as a decorator and painter of seascapes. A group of art-lovers, struck by the quality of his work, paid for his journey to Rome, where he enjoyed great success. In 1753 the Marquis de Marigny commissioned him to do a series of pictures of the French ports. After settling in Paris (in 1777) he built up a large foreign clientèle for his work. Died in 1789.

Bibl.: FL. INGERSOLL-SMOUSE. *Joseph Vernet, peintre de marines.* Paris 1926.

VIEN, JOSEPH.

Born at Montpellier in 1716, the son of a locksmith. He did not go to Paris until 1740. After studying under Natoire, he won the Prix de Rome in 1743 and stayed five years in Rome. On his return to Paris, he found a patron in Caylus who encouraged him to take up encaustic painting. In 1754 he was elected to the Academy and in 1775 appointed Director of the French Academy in Rome. Returning to Paris again in 1781, he was appointed Director of the Gobelins tapestry factory and First Painter to the King. He was received at the Institut de France in 1796, was made Senator and Count in 1808; on his death in 1809 he was given the honors of a 'national funeral' at the Pantheon.

WATTEAU, ANTOINE.

Born at Valenciennes in 1684, where his father was a tiler and carpenter. Apprenticed "to a rather bad painter in the city," named Guérin, he ran away to Paris, where he soon found employment in a wretched workshop near the Pont Notre-Dame with a hack-painter who specialized in cheap religious pictures for a provincial clientèle. This ensured his livelihood while leaving him time enough to draw and sketch on the side. It was not long, however, before he entered Gillot's studio where he made rapid progress and soon his skill excelled his master's. But, though

good friends at first, the two painters soon parted company, and Watteau went to work with Audran, then Keeper of the Luxembourg Palace and a well-known decorator. The young artist learned a good deal from Audran, and even more, perhaps, from the careful study he made of the decorations Rubens had made in the Palace for Marie de' Medici, while in the Luxembourg gardens he found the landscape backgrounds of his future works. After running for the Prix de Rome and failing to do better than a *proxime accessit*, he made a short stay at Valenciennes. Back in Paris, he became friendly with several discriminating connoisseurs who for some time had been watching the young artist with an interested eye: Gersaint, Julienne, and the Comte de Caylus. It was they who, in 1709, introduced Watteau to Crozat, a wealthy collector, at whose residence in the rue de Richelieu the young painter was invited to browse at his leisure among the pictures and sketches in Crozat's collection. Although always jealously guarding his independence, Watteau went to live with Crozat in 1716. Accepted as an associate at the Academy in 1712, he was made a full member in 1717, depositing the *Embarkation for Cythera* as his diploma work. After leaving Crozat, he lived first with Sirois, then towards 1718 shared a house with his friend the painter Vleughels. In 1721 his health, which had never been good, began seriously to deteriorate and he made a trip to London to consult Doctor Mead, a famous specialist. But when he returned to Paris after a few months he was weaker in health than ever. He now went to stay with his friend Gersaint, the picture-dealer, for whom he painted his famous *Enseigne*. After resting in the country, he settled at Nogent in a house lent him by a Monsieur Le Fèvre. But very soon he was hankering to go back to Valenciennes; unfortunately he was in no condition to make the trip. He had just time to paint a *Christ on the Cross* (the picture has disappeared) for the village priest at Nogent,

before he died on July 18, 1721, at the early age of thirty-seven.

Bibl.: EDM. and JULES DE GONCOURT. *Catalogue raisonné de l'œuvre peint, dessiné et gravé d'Antoine Watteau.* Paris 1875. — EDM. and JULES DE GONCOURT. *L'Art du Dix-huitième siècle.* Paris 1859-1875. — *Watteau, L'Œuvre du Maître.* Paris 1912. — L. GILLET. *Watteau.* Paris 1921. — J. ADHÉMAR and ED. MICHEL. *L'Embarquement pour Cythère.* Paris 1939. — R. HUYGHE and H. ADHÉMAR. *Watteau.* Paris 1950.

WILSON, RICHARD.

Born in 1714 at Penegoes in Montgomeryshire, he went to London at the age of fifteen to study painting. After achieving some success as a portrait-painter, he made a trip to Italy in 1749. Though he was a foundation member of the Royal Academy and exhibited there from 1780 on, there was no demand for his landscapes and he was reduced to a meager pittance—the salary of his Librarianship at the Academy. Things became somewhat easier for him after 1776, however, and he was able to retire to the country, where he died in 1782.

ZOFFANY, JOHANN.

Born in 1733 at Frankfurt-am-Main, where his father was architect to the Prince von Thurn und Taxis. At the age of thirteen he ran away from home, ending up in Rome where for the next thirteen years he sketched and painted. In 1758 he went to London where he soon made a name for himself, becoming a foundation member of the Royal Academy in 1769. In 1772 he made a trip to Florence, staying two years. From 1783 to 1790 he lived in India; then returned to England where he died in 1810.

Bibl.: MANNERS, Lady VICTORIA and WILLIAMSON, Dr G. C. *John Zoffany.* London 1920.

GENERAL BIBLIOGRAPHY

HOLMES, Sir Charles. *The National Gallery*, Vol. III. London 1927.

WHITLEY, W.T. *Artists and their Friends in England*, 1700-1799. London, 1901.

ARMSTRONG, Sir Walter. *Sir Henry Raeburn.* London, 1901.

JOHNSON, Charles. *English Painting from the Seventh Century to the Present Day.* London 1932.

GONCOURT, Edmond and Jules de. *L'Art du Dix-huitième siècle.*

GONSE, L. *Les chefs-d'œuvre des Musées de France.* Paris 1900.

MEIER-GRAEFE. J. *Die grossen Engländer.* Munich 1902.

MARCEL, P. *La Peinture française au début du XVIIIe siècle.* Paris 1906.

DUMONT-WILDEN, L. *Le Portrait en France au XVIIIe siècle.* Paris 1908.

DAYOR, A. *La Peinture anglaise.* Paris 1908.

FONTAINE, A. *Les Doctrines d'art en France, de Poussin à Diderot.* Paris 1909.

ROLFS, W. *Geschichte der Malerei Neapels.* Leipzig 1910.

REYMOND, M. *De Michel-Ange à Tiepolo.* Paris 1911.

HAUTECŒUR, L. *Rome et la Renaissance de l'antiquité à la fin du XVIIIe siècle.* Paris 1912.

VAILLAT, L. *La Société du XVIIIe siècle et ses peintres.* Paris 1912.

CHARPENTIER, J. *La Peinture anglaise.* Paris 1921.

OJETTI, U., DAMI, L., TARCHAINI, N. *La Pittura italiana del Seicento e del Settecento alla Mostra di Palazzo Pitti.* Milan-Rome 1924.

LAPAUZE, H. *Histoire de l'Académie de France à Rome.* Paris 1924.

RÉAU, L. *Histoire de l'Expansion de l'art français.* Paris 1924-1933.

RÉAU, L. *Histoire de la Peinture française au XVIIIe siècle.* Paris 1925-1926.

SCHNEIDER, R. *L'art français du XVIIIe siècle.* Paris 1926.

OJETTI, U. *Il ritratto italiano del Caravaggio al Tiepolo.* Bergamo 1927.

RATOUIS DE LIMAY, P. and DACIER, E. *Pastels du XVIIe et du XVIIIe siècles.* Paris 1927.

FIOCCO, G. *Venetian Painting of the Seicento and Settecento.* Florence 1929.

DIMIER, L. *Les Peintres français du XVIIIe siècle.* Paris 1929-1930.

NATALI, G. *Settecento.* Milan 1930.

MOSCHINI, V. *La Pittura italiana del Settecento.* Florence 1931.

ROCHEBLAVE, S. *L'Age classique de l'art français.* Paris 1932.

MOUREY, G. *La Peinture anglaise du XVIIIe siècle.* Paris 1932.

GOLDSCHMIDT, E. *La Peinture française du XVIIIe siècle.* Paris 1932.

ROTHENSTEIN, J. *An Introduction to English Painters.* London 1933.

NOLHAC, P. de. *Peintres français en Italie.* Paris 1934.

GILLET, L. *La Peinture de Poussin à David.* Paris 1933.

ROCHEBLAVE, S. *La Peinture française au XVIIIe siècle.* Paris 1937.

HUYGHE, R. *La Peinture française du XVIIIe au XIXe siècle.* Paris 1938.

RÉAU, L. *L'Europe au siècle des lumières.* Paris 1938.

JAMOT, P. *La Peinture en Angleterre.* Paris 1938.

HOURTICQ, L. *La Peinture française au XVIIIe siècle.* Paris 1939.

DACIER, E. *Le Style Louis XVI.* Paris 1941.

VERLET, P. *Le Style Louis XV.* Paris 1942.

RATOUIS DE LIMAY, P. *Le Pastel en France au XVIIIe siècle.* Paris 1946.

FLORISSOONE. *Le Dix-huitième siècle.* Paris.

VARIOUS AUTHORS. *La Peinture au Musée du Louvre.* N.d.

CONTENTS

THE COLORPLATES

INDEX OF NAMES

THIS VOLUME OF THE COLLECTION "THE GREAT CENTURIES OF PAINTING" WAS
PRINTED UNDER THE TECHNICAL DIRECTION OF EDITIONS D'ART ALBERT SKIRA,
FINISHED THE TWENTY-SIXTH DAY OF MAY NINETEEN HUNDRED AND FIFTY-TWO.

TEXT AND COLORPLATES BY

SKIRA

COLOR STUDIO
AT IMPRIMERIES RÉUNIES S. A., LAUSANNE

FOR SKIRA INC., PUBLISHERS
381 FOURTH AVENUE, NEW YORK 16, N. Y.

PLATES ENGRAVED BY GUEZELLE ET RENOUARD.